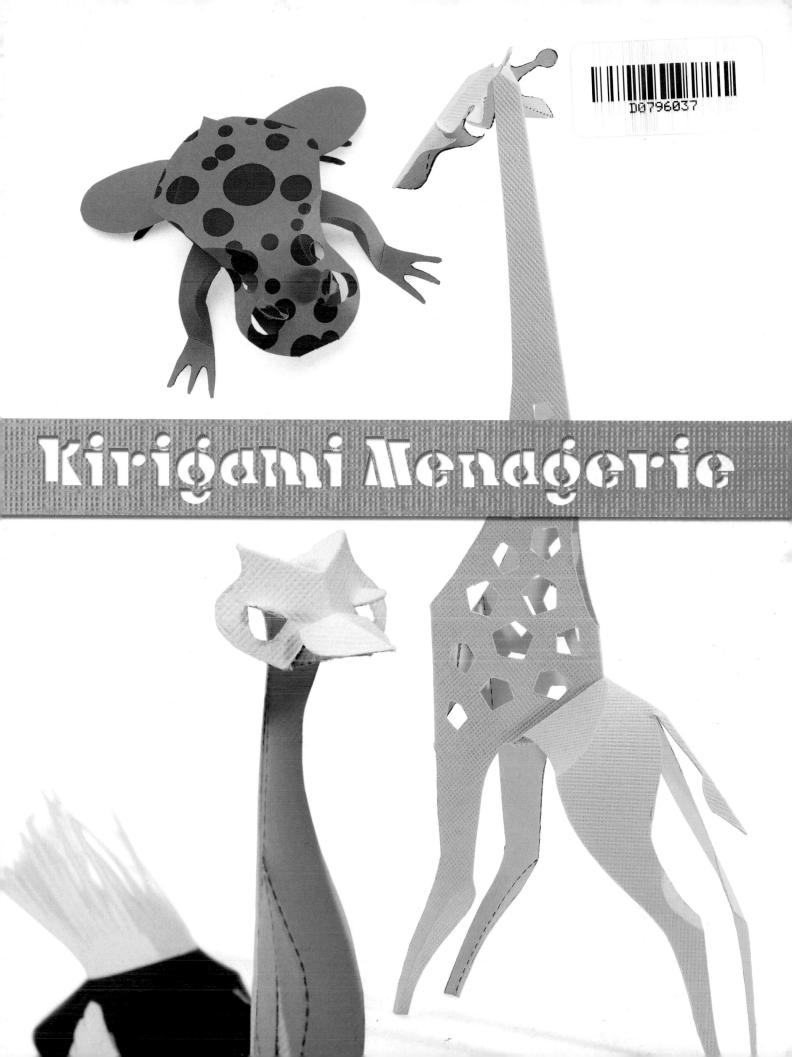

Kirigami Menagerie

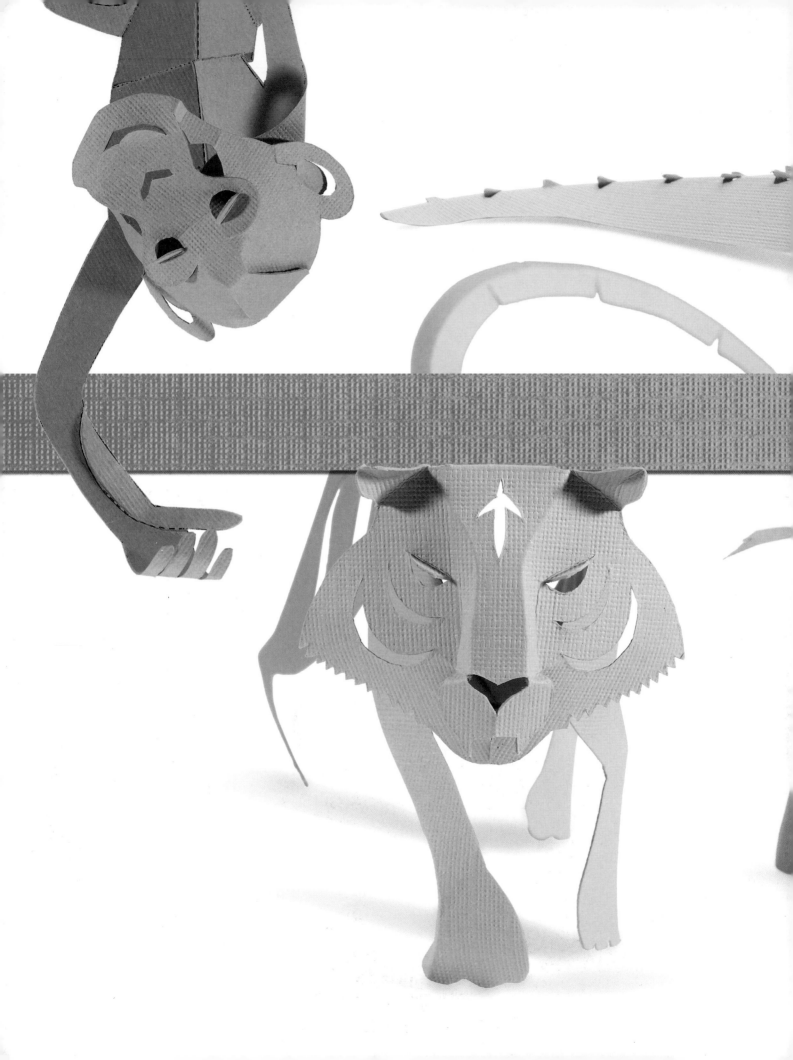

Kirigami Menagerie

38 Paper Animals to Copy, Cut & Fold

Hiroshi Hayakawa

LARK CRAFTS

An Imprint of Sterling Publishing Co., Inc.
New York

Senior Editor: **Terry Taylor**
Editor: **Chris Rich**
Art Director: **Kristi Pfeffer**
Photographer: **Steve Mann**
Cover Designer: **Eric Stevens**

Library of Congress Cataloging-in-Publication Data

Hayakawa, Hiroshi, 1962-
 Kirigami menagerie : 38 paper animals to copy, cut & fold / Hiroshi
Hayakawa.
 p. cm.
 Includes index.
 ISBN 978-1-60059-318-5 (pb-pbk. : alk. paper)
 1. Paper work. 2. Animals in art. I. Title.
 TT870.H382 2009
 736'.98--dc22

 2008050622

10 9 8 7 6 5 4 3 2

Published by Lark Crafts, an Imprint of Sterling Publishing Co., Inc.
387 Park Avenue South, New York, NY 10016

Text and Illustrations © 2009, Hiroshi Hayakawa
Photography © 2009, Lark Crafts, an Imprint of Sterling Publishing Co., Inc.

Distributed in Canada by Sterling Publishing,
c/o Canadian Manda Group, 165 Dufferin Street
Toronto, Ontario, Canada M6K 3H6

Distributed in the United Kingdom by GMC Distribution Services,
Castle Place, 166 High Street, Lewes, East Sussex, England BN7 1XU

Distributed in Australia by Capricorn Link (Australia) Pty Ltd.,
P.O. Box 704, Windsor, NSW 2756 Australia

If you have questions or comments about this book, please contact:
Lark Crafts
67 Broadway
Asheville, NC 28801
828-253-0467

Manufactured in China

ISBN 13: 978-1-60059-318-5

For information about custom editions, special sales, premium and corporate
purchases, please contact Sterling Special Sales Department at 800-805-5489
or specialsales@sterlingpub.com.

For information about desk and examination copies available to college and
university professors, requests must be submitted to academic@larkbooks.com.
Our complete policy can be found at www.larkcrafts.com.

Contents

Introduction6

How to Use This Book
Working with the Templates7
Paper .7
Symbols8
Scoring8
Cutting9
Folding11
Shaping12
Coloring13
Selecting an Animal13

The Animals
Very Easy
King Cobra14
Mouse16
Sheep18
Terrier20

Easy
Rabbit22
Giant Panda24
The Boar Bunch27
Giraffe30
Frog32

Intermediate
Cow34
The Pig Family36
The Lion Pride39

Horse43
Hippo46
The Kangaroo Clan48
Gorilla51
Cheetah54
Ostrich56

Advanced
The Elephant Herd58
Owl62
Alligator65
Cardinal68
Cat70
Armadillo72
Chimpanzee75
Crab78
Rhinoceros80
Tiger83

Very Advanced
Rooster86
Zebra90
Dragon93

Templates96
Acknowledgments128
Index128

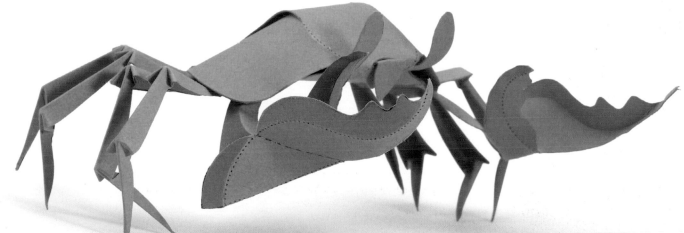

This book is dedicated to the memories of Sachiko Hayakawa and Elsie Varga, who wished that this book would some day become a reality.

Introduction

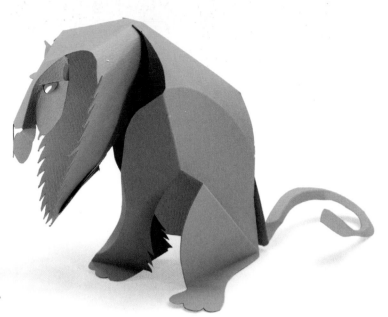

Kirigami—what's that? Well, it's actually a combination of two Japanese words: *kiri*, which means "cutting" and *gami* (or *kami*), which means "paper." Kirigami is a traditional, two-dimensional Japanese paper craft (think of those snowflakes you cut out as a child). Origami, a more familiar craft, focuses on the process of folding (*ori*) paper instead of cutting it, creating dimension and depth.

In this book, I'll show you how to combine these two traditional art forms to create delightful three-dimensional kirigami animals. The technique involves three very distinct processes—scoring, cutting, *and* folding. Notice I didn't mention adhesives. Believe it or not, no glue or tape is required to build these animals; they're held together completely with interlocking joints. Most are strong enough to stand alone; animals that are made to look as if they're flying or running—such as the Ostrich or Cheetah—require simple props to convey movement.

Before you pick up a pair of scissors and start cutting, read the section on how to use this book. At first glance, kirigami may seem a little intimidating, but the process—scoring and cutting the paper templates, then folding and shaping them—is really quite simple. Familiarize yourself first with the basic steps, and then follow the specific instructions for the animal you choose to make.

And what a menagerie you have to choose from! I suggest you start with the easiest animals before you work your way to the more complex creatures. Make a pond full of Frogs (page 32) in every color of the rainbow, or fold a flock of Sheep (page 18) to count while you fall asleep. Create a Kangaroo family (page 48) or a pride of Lions (page 39) before you tackle the trickier Rhinoceros (page 80), crowing Rooster (page 86), or fanciful Dragon (page 93).

I've also included templates for various props and extras (such as bamboo trees), if you'd like to create a little scene for your creatures. Others are online at www.larkbooks.com/crafts: make cheese for mice and a fence for farm animals. Online you'll also find texture patterns for you to print and copy to give your animals an appropriate or imaginary hide. Who says you can't make a scaly pink cat or polka-dotted owl?

With a little practice, you'll find that turning a flat sheet of paper into a three-dimensional animal is both meditative and magical. I hope you enjoy making these animals just as much as I enjoyed designing them.

—Hiroshi Hayakawa

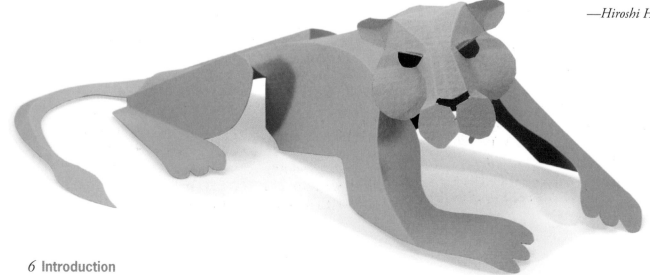

How to Use This Book

Although the animal designs in this book are all different, the first two steps in making them—scoring and cutting—are exactly the same. I've described these steps here rather than repeating them in every set of project instructions, so please read this section thoroughly before you begin. Also described in this section are the basic techniques for folding, shaping, and coloring, as well as special tips that will help you along the way.

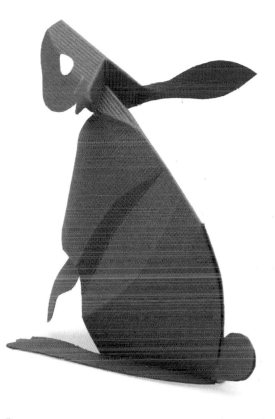

Working with the Templates

Templates for every animal are provided on pages 96–127. Keep in mind that they are printed on the reverse side (or underside) of the paper. Cut and score on the printed side. Once you've constructed the animals, most of the printed folding lines won't be visible on their outer surfaces.

Photocopy the templates instead of using the originals. This way, you'll be able to make as many animals as you like. Another great idea is to make colorful friends for your animals by photocopying the templates on the colored craft paper of your choice. Build a diorama, and make up stories to go with the scenes! The possibilities are endless.

Templates of special displays for some of the animals are online (although bamboo for the Tiger is included in the back of the book), but by all means, be creative. Improvise and come up with your own unique paper landscapes, or create landscapes from found objects. Have fun displaying your animals!

Check out www.larkbooks.com/crafts for an assortment of mix-and-match texture patterns that you can use to give your animals different "skins." How about scales for your Hippo? Or frog skin for your Elephant? To use one of the texture patterns, just photocopy it onto the opposite side of the animal template that you want to work with.

Paper

The type of paper you should use for copying project templates needs to be thin enough to be easily folded but thick enough to give structural strength so the assembled projects can be freestanding. All of the projects in this book were made with cardstock paper that you can easily find at your local copy shop or craft store.

There are a variety of cardstock thicknesses, colors, shades, and textures to choose from. Stay away from less expensive cardstock that may have a white core in the center; when you score and fold it, the white core will appear in your fold. To photocopy or print on cardstock, adjust the paper setting and hand feed the paper one at a time to avoid jamming.

Symbols

As you work on the projects, you'll need to understand the symbols that appear on the templates and in the illustrations that come with the project instructions. These are shown and described below.

A transition from one step to the next

Move a part of the template or a tool in the direction of the arrow.

Movement occurs toward/on the reverse side of the template.

Turn over a part of the template, reversing the inside/ outside relationship.

Create a rounded surface with a dowel (page 12).

Create a curved surface with a dowel. The arrow indicates the general shape and direction of the curve.

Enlarged view of a smaller section

Indicates ups and downs of the surface levels after a series of folds

Turn over the entire template.

Awl used for scoring

Scoring

The first step in making a kirigami project is scoring the folding lines (the dashed and dotted lines) on the template (figure 1). Scoring makes folding easier and neater later on. If you cut out the template first, scoring these lines, especially in small, delicate areas, is sometimes more difficult, so it's best to score first.

Begin by placing the template on a smooth, flat, hard surface. A surface that's too soft, such as newspaper, may cause you to dig deep grooves in the template as you score, which would make the assembled animal unsightly.

The key to successful scoring is to avoid exerting too much pressure on your scoring tool. Score the folding lines with an awl, a small nail, a bone folder, a ballpoint pen that's run out of ink (finally—a use for one!), or anything with a hard, pointed tip. Even though some of the scored lines will be folded downward and others will be folded upward, score them all on the same side of the template. Try not to stray from the marked lines.

To make scoring straight lines easier, use the edge of a ruler as a guide (figure 2).

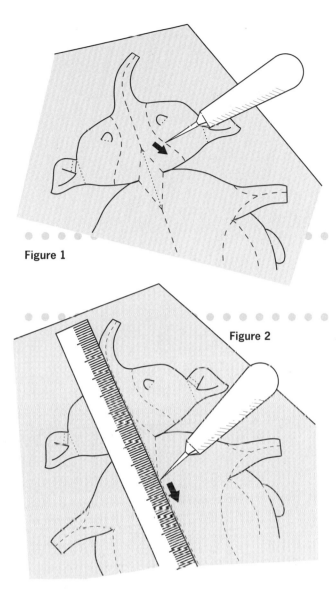

Figure 1

Figure 2

Next, use scissors or a craft knife to cut along the contour perimeter of the template (figure 4).

When cutting away small, sharp areas that extend beyond the template's contour but toward the interior (the Baby Elephant's tail shown in figures 5 and 6 is a good example), first use scissors to make a rough cut (figure 5), and then cut away the remaining paper with

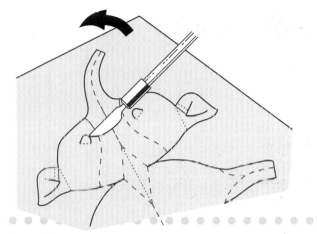

Figure 3

Cutting

The next step is cutting. The solid lines on the templates represent the cutting lines.

First, use a craft knife to cut along all the solid lines within the interior perimeter of the template. These lines include small cuts along the eyelids, the body markings of some animals, and the cutting lines of the tabs for interlocking joints. When making small, curved cuts such as those for the eyelids, rotate the paper in the opposite direction as the movement of your knife (figure 3).

Be very careful when using a craft knife; keep your hands away from the path of the blade. A small child may need an adult's help when making precision cuts.

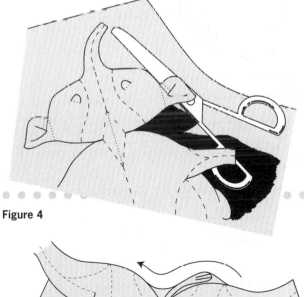

Figure 4

Figure 5

Figure 6

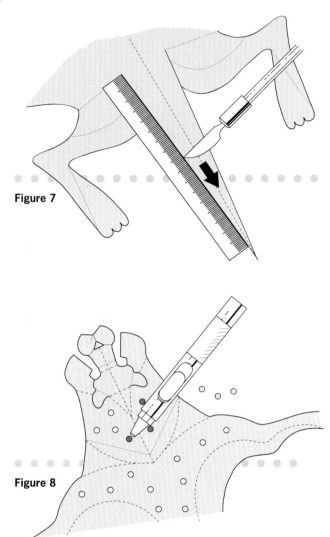

Figure 7

Figure 8

a craft knife, moving the instrument from the interior toward the exterior (figure 6). Remove the template from the page.

Cutting a straight line is easy. Use the edge of a ruler as a guide—the same as when you're scoring a straight line—and cut along the line with a craft knife (figure 7). Use a metal ruler so that you don't damage its edge with the knife.

To cut out small circles such as the eyes of the Armadillo (page 72) or the body markings of the Cheetah (page 54), you can use a craft knife, but the best tool for this job is a paper (or leather) punch (figure 8). Align the tip of the punch with the circle and gently tap the end of the punch with a wooden or rubber mallet.

Folding

After scoring and cutting out the template, you'll create the animal shape by folding it. Two types of folds are used in this book—the *mountain fold* and the *valley fold*. A mountain fold is represented by a dotted line, a valley fold by a line of dashes. Most folding can be done with your fingers, but small, delicate sections will require a little help from some tools.

Making a Mountain Fold

Use the index finger and thumb of one hand to push down on both sides of the dotted line, while simultaneously pushing up the area under and along the folding line with the edge of one finger of your other hand (figure 9). If the section of the template that calls for this type of fold is too small to allow you to use the edge of your finger, use a small tool, such as a toothpick, or the needle or awl that you used for scoring.

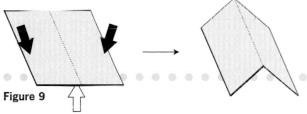

Figure 9

Making a Valley Fold

Use one finger to push down along the dashed line of the template, while pushing up along both sides of the folding line with the index finger and the thumb of your other hand (figure 10). Again, if the section to be folded is too small for your finger, push down the folding line with a small scoring tool instead.

Figure 10

Folding a Curved Line

To fold along a line that isn't straight, use your thumb and index finger to pinch and squeeze along opposing sides of the folding line (figure 11).

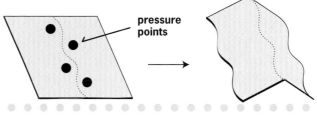

pressure points

Figure 11

Making a Pocket Fold

Pocket folding—a combination of a mountain fold and a valley fold—is used to form the neck-shoulder and tail-hip connections of many animals in this book. Figure 12 illustrates how to make this fold.

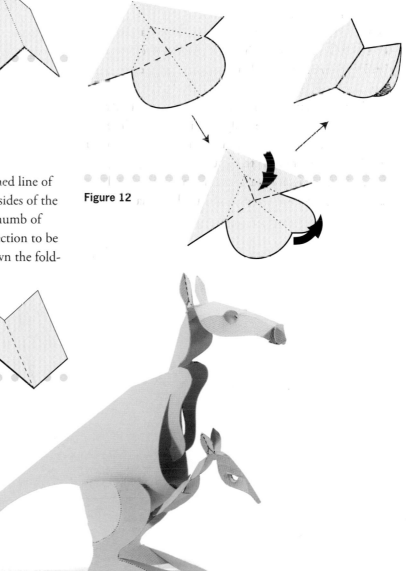

Figure 12

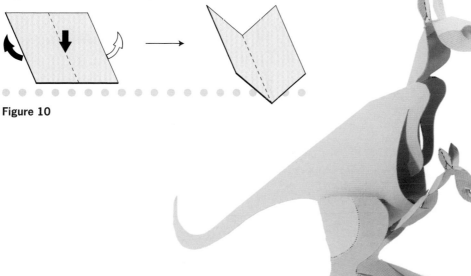

Shaping

Following are some techniques that you can use to create better shapes for your animals. These techniques aren't applicable to all the animals in this book, but using them adds an extra sense of realism and a certain air of elegance to some.

The first technique is used to round the body of an animal. After cutting out the template, turn it over. Use one hand to press the template against the edge of a desk or table and use the other hand to pull it back and forth across the edge a couple of times (figure 13). This will add a natural curve to the animal's body.

To create a nice, smooth curve in a small area of a template, roll it over a dowel (figures 14 and 15). A dowel produces a much neater result than rolling the template with your fingers. If you don't have one, substitute a round pencil or any other thin, tubular object.

Many of the animals in this book are held together by means of interlocking joints (figure 16). They make it possible to assemble the animals without using glue or tape and provide them with enough strength to make them freestanding.

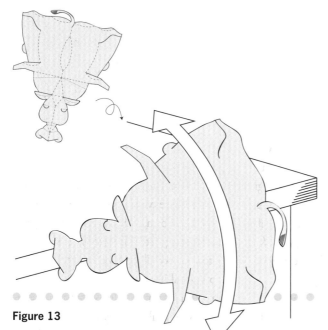

Figure 13

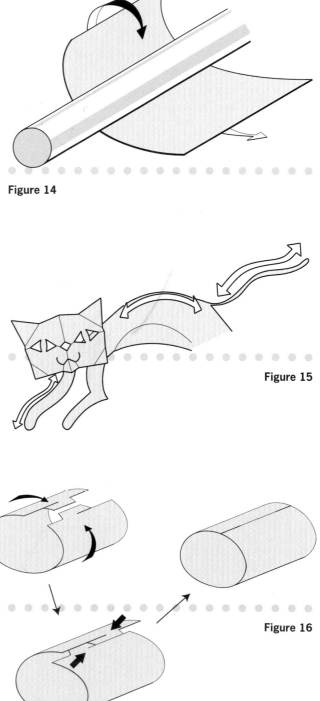

Figure 14

Figure 15

Figure 16

Coloring

Simply cutting out the designs creates unique body markings on many of the animals, such as the stripes on the Tiger (page 83). A few of the animals—including the Rooster, Giant Panda, Ostrich, and Cardinal—require special coloring instead. The locations and/or shapes of the markings on these animals are difficult to create by cutting.

Coloring instructions are included within the individual project instructions. The areas that should be colored or painted are represented by black fill (figures 17 and 18).

Use any opaque paint or drawing medium, as long as it isn't oil based. Acrylic paints, colored pencils, and pastels will all work just fine.

You can color any of the animals, of course, in any way you like. In fact, painting or coloring the markings rather than cutting them out is a good option for small children who aren't comfortable working with craft knives.

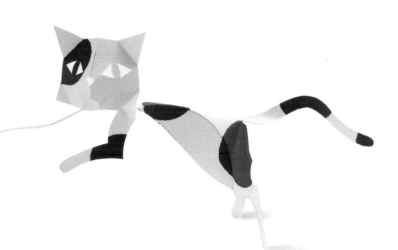

Selecting an Animal

The animal projects range from ones that are very easy to make right up to some that require advanced skills. If you have very little experience with paper-cutting and folding crafts, or if you're a youngster, I recommend getting your feet wet by starting with the simpler animals. Gradually move on to more challenging ones as you practice and develop your skills.

Most of the animals in this menagerie stand on their own feet. There are a few animals, though, that aren't self-supporting, like the Ostrich, Cheetah, and Rooster. That doesn't mean you shouldn't make them. On the contrary, those are the very ones you'll probably want to make!

It's easy to give support to these animals with only a little effort. All you need is a short length of 16 gauge steel wire, a pair of pliers, and a block of scrap wood or foam. Some animals are also threaded so they appear to fly.

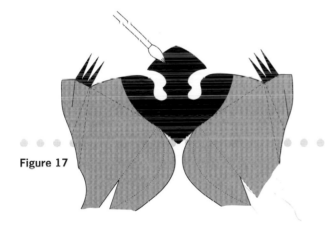

Figure 17

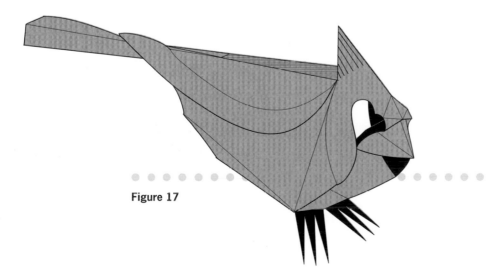

Figure 17

To see a cobra can be quite alarming,
But, don't fret, humans they avoid harming.
They eat only snakes,
Take long "walks" by the lake.
In fact, they're really quite charming!

King Cobra

1. Score and cut the King Cobra template on page 98, using the basic instructions provided on pages 8–10. Remember to cut out the eyes with a craft knife or punch.

2. Begin assembling the Cobra by folding along the scored lines.

3. To round the Cobra's neck, roll the front of the template over a dowel in the area indicated in figure 1.

4. Curl the split tongue upward in a similar fashion (figure 2). Paint the tongue red.

Tip

If you'd like to add scales to your Cobra, print the scales pattern provided online onto the blank side of the King Cobra template. Once you've finished assembling the Cobra, the scales will appear on its outer surface.

Figure 1

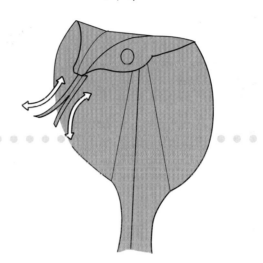

Figure 2

Mouse

Squeaked a humble mouse, "Okay, so...
We gotta shed our kind's status quo
That mice are monsters, do you see?
Good idea? Fait accompli?
We've got lots to show, so off we go."

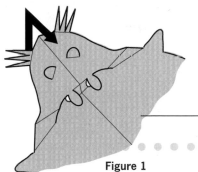

Figure 1

1. Score and cut the Mouse template on page 99, following the basic instructions provided on pages 8–10.

2. Assemble the Mouse by folding along the scored lines. Be sure to make the mountain and valley folds correctly.

3. Pull the head up and push it back toward the shoulders, following the folding lines on the neck. Pull up the eyelids, whiskers, and ears (figure 1). Then fold the head and body in half along the centerline.

4. Roll a dowel against the underside of the body to round the body toward the tail (figure 2).

5. Interlock the tabs at the tail. Then pull the tail up and add a little curve to shape it (figure 3).

Tip

If you'd like to serve your mouse a piece of delicious cheese, download the template at www.larkbooks.com/crafts.

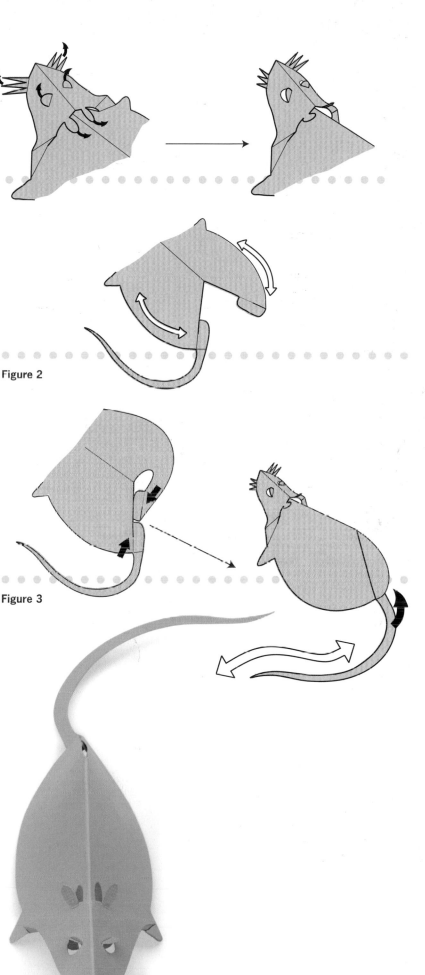

Figure 2

Figure 3

As they graze, sheep gladly devour
Any grass, grain, or wildflower.
The flock must beware,
When they're washing their hair,
It may shrink when they take a hot shower.

Sheep

1. Score and cut the Sheep template on page 97, following the basic instructions provided on pages 8–10. Remember to cut the nose opening.

2. Fold along the scored mountain and valley lines carefully. Fold the head first, pulling up the eyelids and shaping the ears (figure 1).

3. Fold the body in half along the centerline. Then pocket-fold the neck into the shoulders (figure 2).

4. Shape the legs (figure 3).

5. Interlock the belly joint (figure 4).

Tip

Sheep have many different body types and markings. The photograph on the facing page shows some variations, but color your sheep however you want.

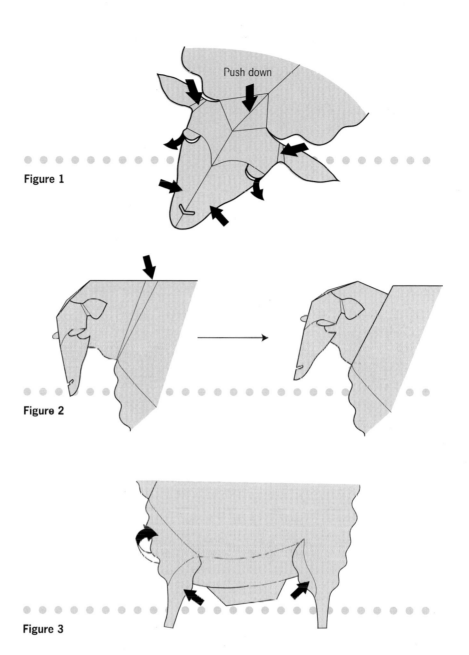

Figure 1

Figure 2

Figure 3

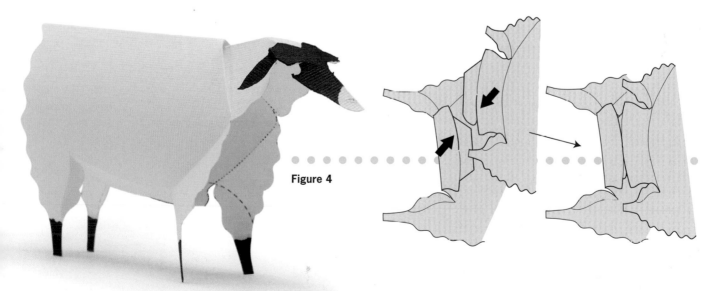

Figure 4

Spaniel, Schnauzer, Poodle, Harrier,
Pointer, Pinscher, St. Bernard, Terrier
Some may ask why there needs
To be so many dog breeds.
To which we say, "the more the merrier."

Terrier

Figure 1

Figure 2

Figure 3

Figure 4 Bottom View

Figure 5

1. Score and cut the Terrier template on page 99, following the basic instructions provided on pages 8–10.

2. Fold along the scored mountain and valley lines carefully. Start working on the head by pulling up the eyelids; then roll the ears against a dowel to round them. Push back the muzzle toward the cheeks. Push the top of the head down as you fold the body in half along the scored centerline (figure 1).

3. Fold in the tabs on the chest, front legs, and hind legs, and fold the tail upward (figure 2).

4. Interlock the chest joint (figure 3).

5. Interlock the leg joint (figure 4).

6. Swing the tail up to the side. Fine-tune its shape and angle so that the bottom of the dog sits comfortably on a flat surface (figure 5).

Extras

Download templates for the Pug and French Bulldog online at www.larkbooks.com/crafts.

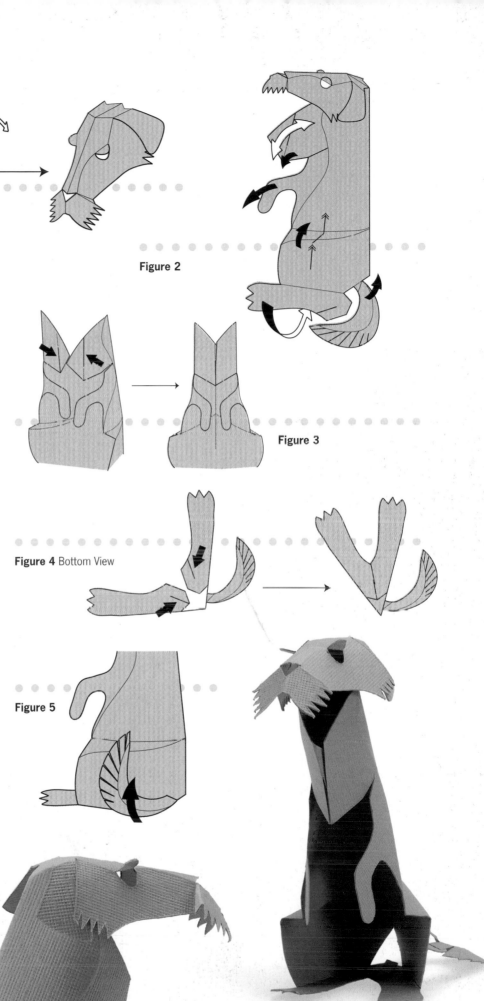

Rabbit

Aside from the tortoise's defeat,
The hare is one of the lucky elite.
It eats four leaf clovers…
And plays, but moreover,
It carries around four rabbit feet.

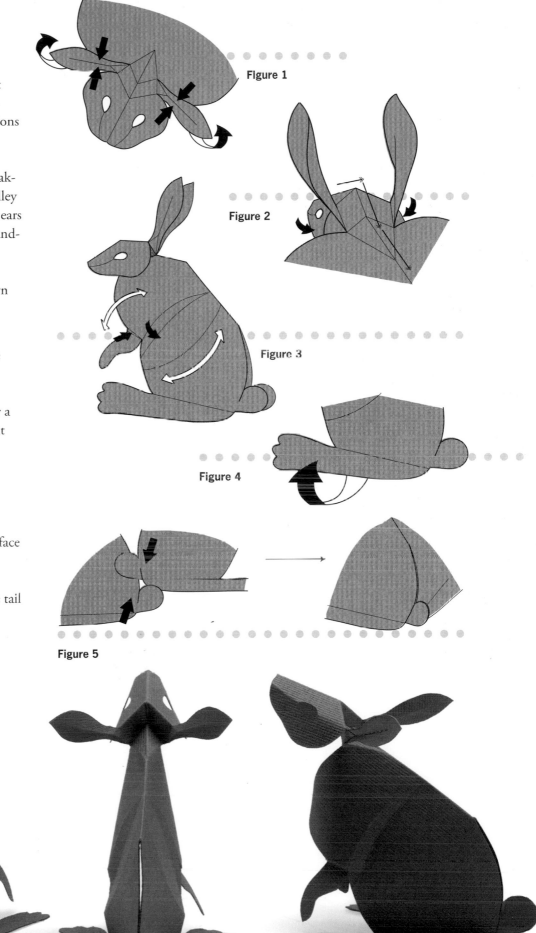

1. Score and cut the Rabbit template on page 97, following the basic instructions provided on pages 8–10.

2. Fold the scored lines, making the mountain and valley folds carefully. Pinch the ears and pull them up to a standing position (figure 1).

3. Shape the head, as shown in figure 2.

4. Fold the body along the scored centerline. Then round the chest and the hips by rolling them over a dowel, and push the front legs down toward the stomach (figure 3).

5. Fold the hind legs up so that the rabbit will sit comfortably on a flat surface (figure 4).

6. Interlock the tabs of the tail joint (figure 5).

Figure 1

Figure 2

Figure 3

Figure 4

Figure 5

Although pandas like to eat bamboo,
That's not all they're apt to chew.
Yams and eggs and sea bass,
Plus shrimp and pheasant under glass…
Okay, those last few might be untrue.

Giant Panda

1. Score and cut out the Giant Panda template on page 96, following the basic instructions provided on pages 8–10. Remember to include the nose marks and the marks around the eyes.

2. Fold along the scored lines, making the mountain and valley folds carefully. Roll the muzzle and the jaw over a small dowel to round to them (figure 1).

Figure 1

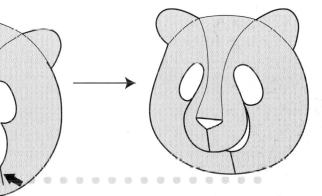

Figure 2

3. Interlock the two head joints, first the one on the muzzle and then the one on the lower jaw (figure 2).

4. Shape the body, the legs, and the tail (figure 3).

Push down

Push in

Push in

Figure 3

5. Interlocking the two joints on the underside of the body (at the chest and belly) is easier if you first round the body by rubbing it against the edge of a table. Interlock the tabs of the two joints when you're finished (figure 4).

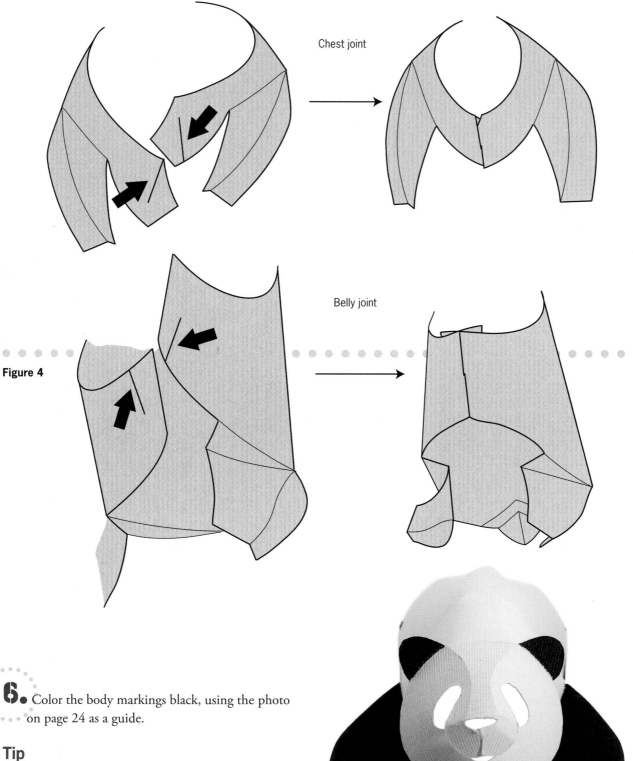

Chest joint

Figure 4

Belly joint

6. Color the body markings black, using the photo on page 24 as a guide.

Tip

To display your panda in a forest of bamboo, make several photocopies of the Bamboo template on page 103, and turn to page 85 for assembly instructions.

Wild boars are commonly sighted,
From Indonesia to States United…
Or spied in Red Square
At a social affair…
To which, of course, they've not been invited.

The Boar Bunch

Adult Boar

1. Score and cut the Adult Boar template on page 100, using the basic instructions provided on pages 8–10.

2. Fold along the scored lines, making the mountain and valley folds carefully. Pocket-fold the nose and round the muzzle by pushing it downward (figure 1).

3. Shape the ears. Roll the tusks and raise them (figure 2).

4. Work on the body next, and push down the tail (figure 3).

5. Interlock the tabs on the belly (figure 4).

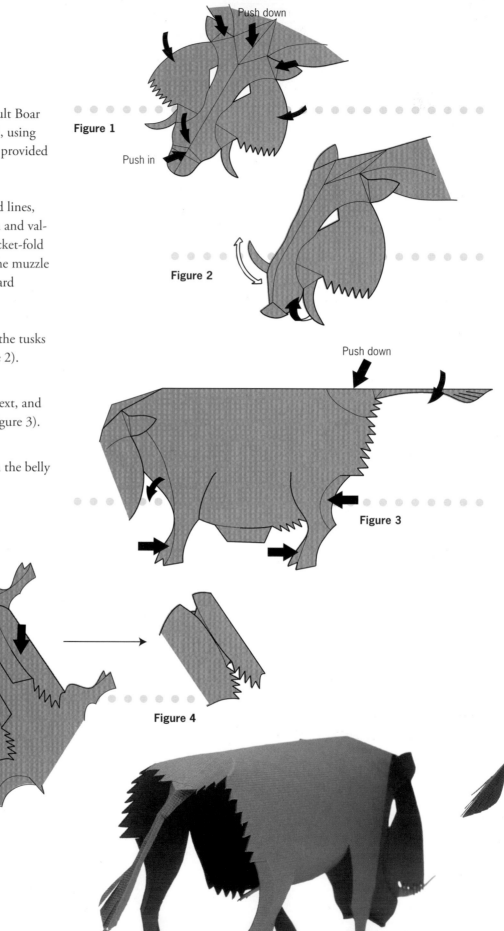

Push down

Figure 1

Push in

Figure 2

Push down

Figure 3

Figure 4

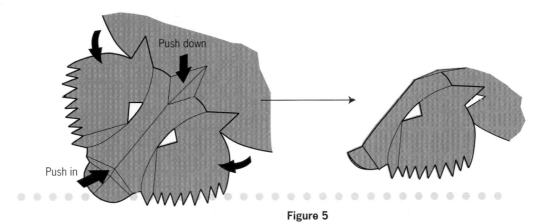

Figure 5

Baby Boar

1. Score and cut the Baby Boar template on page 101, using the basic instructions provided on pages 8–10.

2. Fold along the scored lines, making the mountain and valley folds carefully. Pocket-fold the nose and round the muzzle by pushing it downward (figure 5).

3. Work on the body next and push down the tail (figure 6).

4. Interlock the tabs on the belly (figure 7).

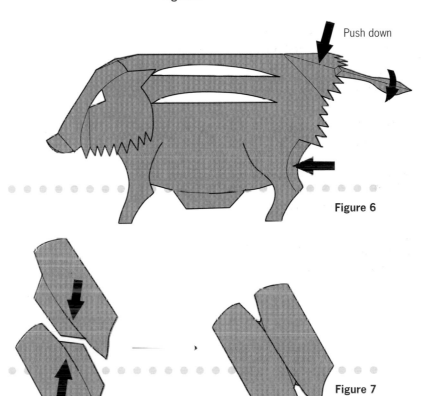

Figure 6

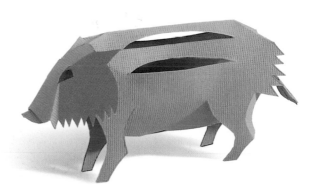

Figure 7

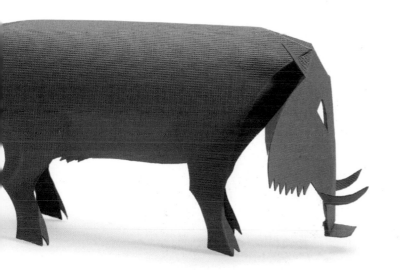

Giraffes have seven bones in their necks
Same as us, but their heart's more complex.
An arrangement of veins
Keeps blood from flooding their brains,
So they can drink water without ill effects.

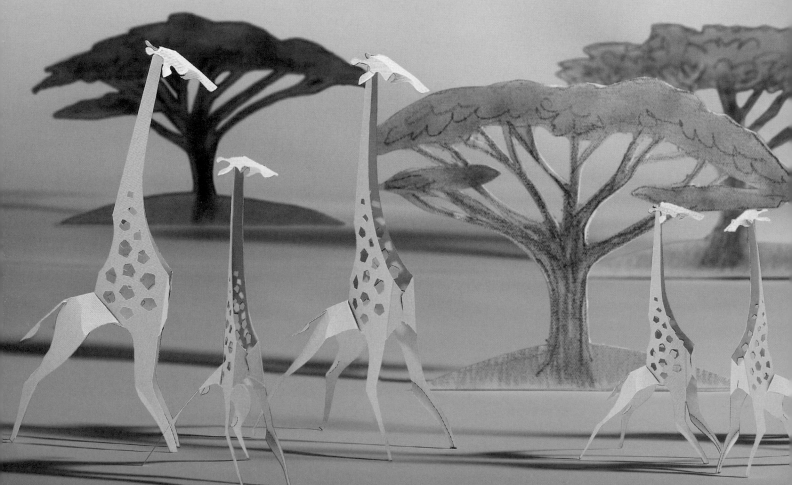

Giraffe

1. Score and cut the Giraffe template on page 102, following the basic instructions provided on pages 8–10.

2. Fold the giraffe in half along the scored centerline. Push up the lower half of the body, and pocket-fold it over the bottom of the upper body (figure 1). Pull out the top of the legs, and round the hips.

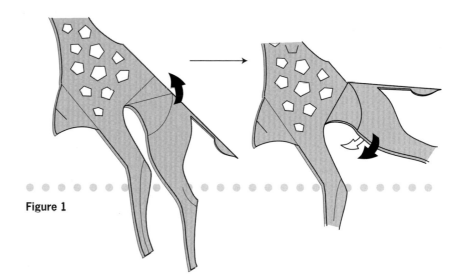

Figure 1

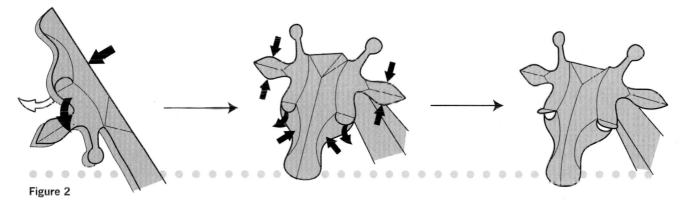

Figure 2

3. To shape the head, first unfold it and push the nose down. Then pull up the eyelids, squeeze in the nose a little, and pinch the ears to add dimension (figure 2).

4. Interlock the chest tabs, and squeeze the joints of the hind legs along the scored lines to strengthen them so the giraffe will stand up straight (figure 3). Fold the forelegs in half along the scored lines, too.

Figure 3

An amphibian, let's call him Fred,
Has princesses kissing his head.
With hope he'll transform,
Yet, he's still forlorn.
Why can't he meet a nice frog girl instead?

Frog

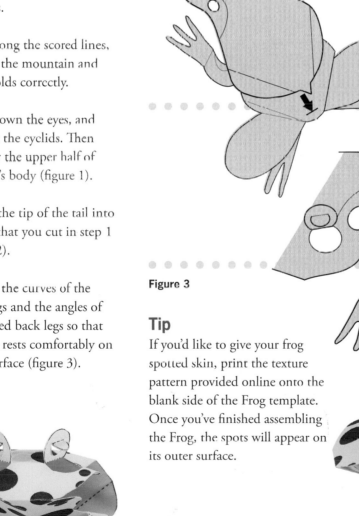

1. Score and cut the Frog template on page 103, using the basic instructions provided on pages 8–10. Remember to cut the lines of the eyes and ears.

2. Fold along the scored lines, making the mountain and valley folds correctly.

3. Push down the eyes, and pull out the eyelids. Then flip over the upper half of the frog's body (figure 1).

4. Insert the tip of the tail into the slit that you cut in step 1 (figure 2).

5. Adjust the curves of the front legs and the angles of the folded back legs so that the frog rests comfortably on a flat surface (figure 3).

Figure 1

Figure 2

Figure 3

Tip

If you'd like to give your frog spotted skin, print the texture pattern provided online onto the blank side of the Frog template. Once you've finished assembling the Frog, the spots will appear on its outer surface.

Think of the powers cows wield,
Each one outstanding in a field.
They jump over the moon,
Could seize the food supply soon.
World leaders would be forced to yield.

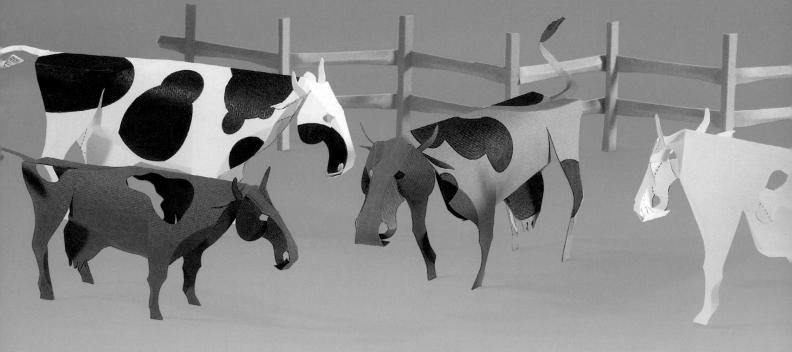

1. Score and cut the Cow template on page 106, using the basic instructions provided on pages 8–10. Remember to include the eyes, nostrils, and body markings.

2. Fold along the scored lines, making the mountain and valley folds carefully. Roll the cheeks and the muzzle against a dowel to round them. Pinch the ears and raise the horns (figures 1 and 2).

3. Roll the horns to curve them, using the rear view of the neck in figure 3 as a guide.

4. Work on the body next. Shape it and the legs (figure 4). Push down the top of the hips, and bring the tail up.

5. Interlock the tabs on the belly (figure 5).

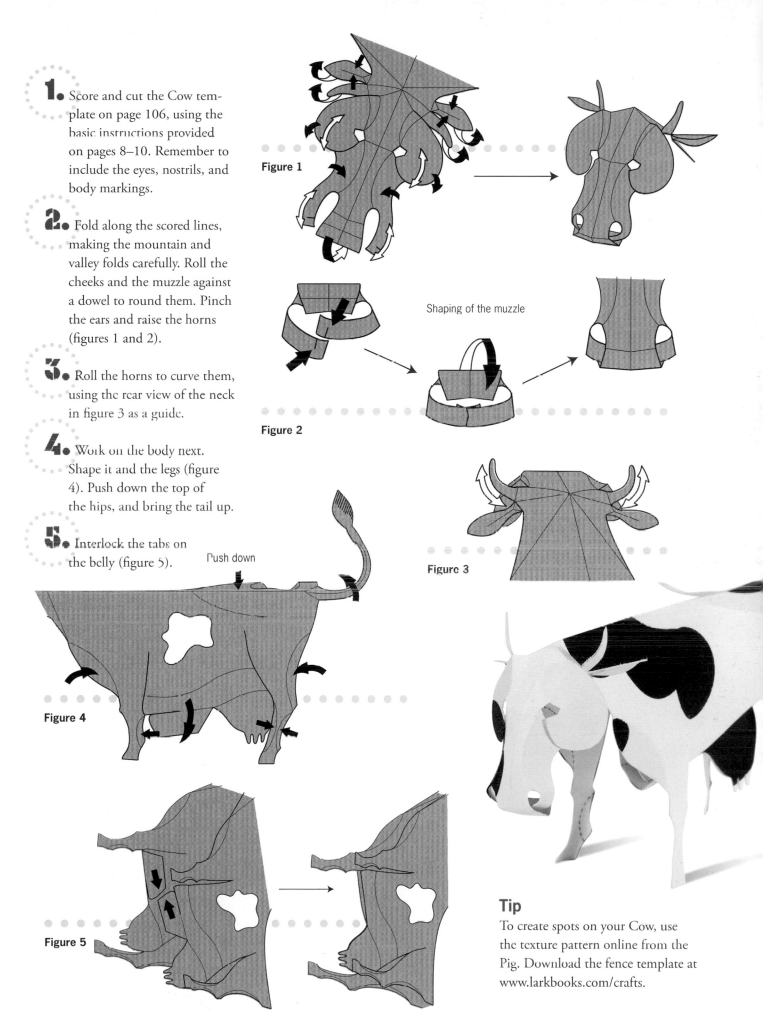

Figure 1

Figure 2

Shaping of the muzzle

Figure 3

Push down

Figure 4

Figure 5

Tip

To create spots on your Cow, use the texture pattern online from the Pig. Download the fence template at www.larkbooks.com/crafts.

Pigs keep hope. The day will exist,
You shall be beloved and kissed.
Silk purses in pairs
Will fly through the air.
On two legs, they'll be called "chauvinists."

The Pig Family

Adult Pig

1. Score and cut the Adult Pig template on page 104, using the basic instructions provided on pages 8–10.

2. Fold along the scored lines, making the mountain and valley folds carefully. Shape the ears by pinching them, and pull up the eyelids. Fold the end of the nose in half, and lift it toward the face (figure 1).

3. Turn the nose back over the bottom of the face, and slide the nose tabs under the jaw (figure 2).

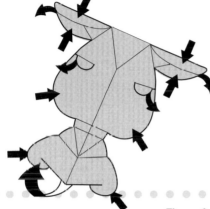

Figure 1

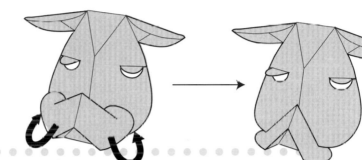

Figure 2

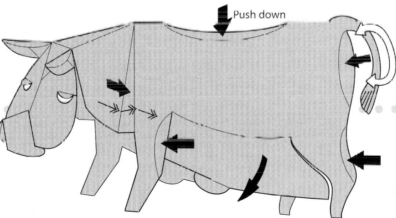

Push down

Figure 3

4. Work on the body next. Push down the back and curl the tail (figure 3).

5. Interlock the tabs on the belly (figure 4).

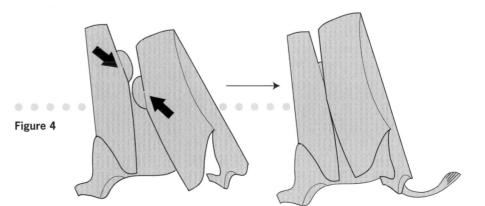

Figure 4

Piglet

1. Score and cut out the Piglet template on page 104, following the basic instructions provided on pages 8–10.

2. Fold the scored lines, making the mountain and valley folds carefully. Open up the eyes by lifting the eyelids. Pull up the nose and turn it over (figure 5).

3. Pull up the ears and push the cheeks back over the shoulders (figure 6).

4. Shape the body and curl the tail (figure 7).

5. Interlock the tabs of the belly joint (figure 8).

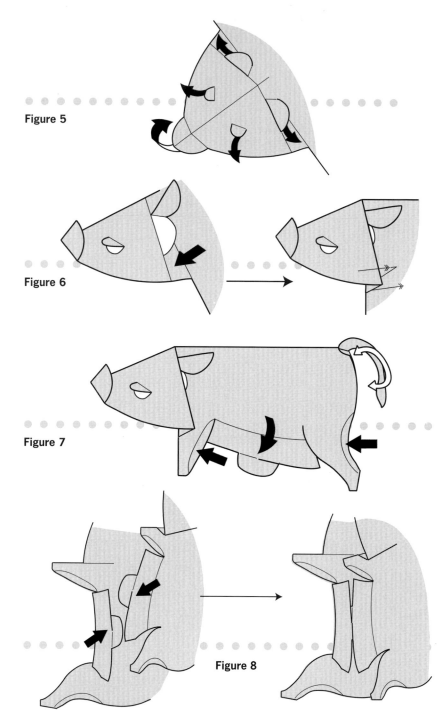

Figure 5

Figure 6

Figure 7

Figure 8

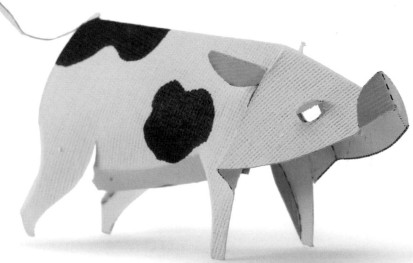

Tip

If you'd like to add spots to your Pig, print the pattern provided online onto the blank side of the Pig template. Once you've constructed the Pig, the spots will show up on its exterior. If you prefer, you can paint the spots instead.

The Lion Pride

Lions used to roam worldwide,
But today they prefer to reside
Where the weather is hot,
And gazelles can be caught.
Hurray, they've still got their pride.

1. Score and cut the Lion template on page 107, using the basic instructions provided on pages 8–10.

2. Fold along the scored lines, making the mountain and valley folds carefully. Pull up the eyelids, and squeeze the sides of the nose so it rises above the cheeks. Pinch the ears to make them stand up. Push the muzzle back toward the cheeks, and roll the cheeks with a dowel to round them (figure 1).

Figure 1

Figure 2

3. Roll a dowel against the underside of the mane. Then interlock the tabs at the bottom of the mane (figure 2).

4. Push the head down lower than the shoulders by pressing down on the center of the mane at its top. Turn the outline of the mane into a heart shape (figure 3).

Figure 3

Figure 4

5. Move on to the body. After shaping the front and hind legs, interlock the back joint at the hips (figure 4). Shape the tail and swing it to one side by folding it at its root.

6. Fine-tune the shape of each foreleg to form an S shape from the shoulder down to the paw (figure 5).

Figure 5

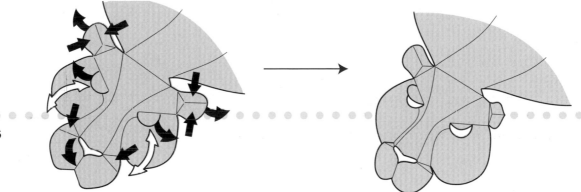

Lioness

1. Score and cut the Lioness template on page 108, using the basic instructions provided on pages 8–10.

2. Fold along the scored lines, making the mountain and valley folds carefully. Using figure 6 as a guide, pull up the eyelids, and squeeze the sides of the nose so it rises above the cheeks. Pinch the ears to make them stand up. Push the muzzle back toward the cheeks, and round the cheeks by rolling them on a dowel.

Figure 6

3. Move on to the body of the Lioness, which is asymmetrical. Note that it must be folded differently on each side. Shape the front legs, and roll the flap of the neck in toward the chest (figure 7).

4. Work on the hind legs next (figure 8). Then adjust the angles of all four legs so that they make good contact with and sit comfortably on a flat surface.

5. Interlock the tabs at the belly (figure 9).

6. Shape the tail (figure 10).

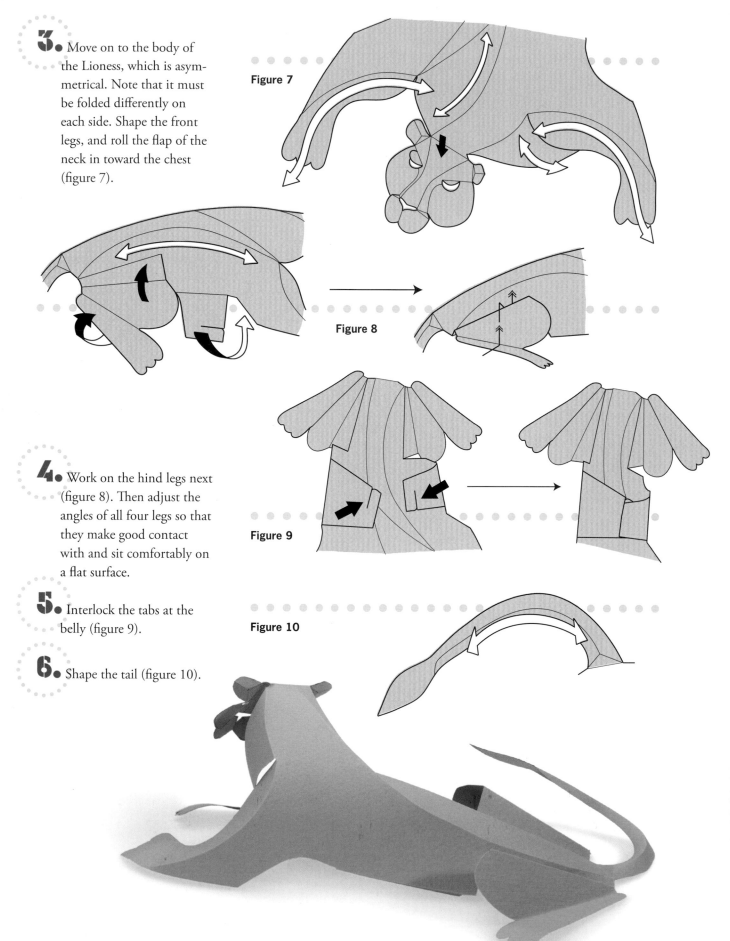

Figure 7

Figure 8

Figure 9

Figure 10

Horses, known in Latin as *equus*,
Carry police on their backs to protect us.
Required for polo,
Star of the rodeo,
And they ask only oats for their breakfast.

Horse

1. Score and cut the Horse template on page 109, using the basic instructions provided on pages 8–10. Remember to cut out the eyes and the triangular opening between the neck and shoulders.

2. Fold along the scored lines, making the mountain and valley folds carefully. Referring to figure 1, pinch the ears to make them stand up straight. Then roll the cheeks and the muzzle.

3. Shape the back of the neck (figure 2).

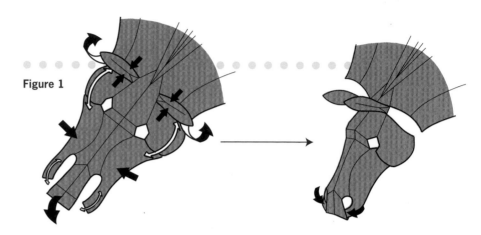

Figure 1

Frontal view of the neck

Figure 2

4. Interlock the tabs on the underside of the neck (figure 3).

5. Move on to the body (figure 4), pushing down the back and pulling up the tail.

6. Interlock the tabs on the belly (figure 5).

Tip

To make the fence shown in the photo, download the template at www.larkbooks. com/crafts.

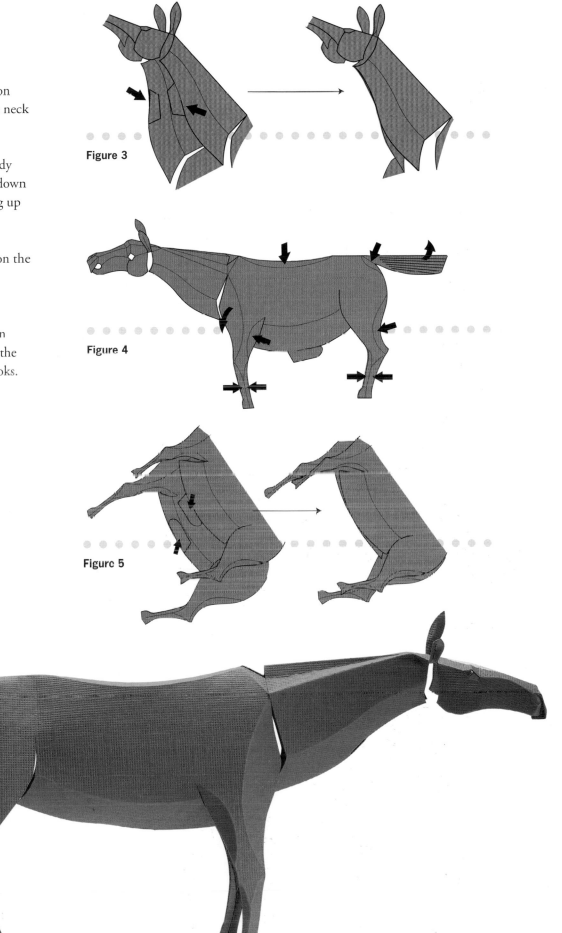

Figure 3

Figure 4

Figure 5

Hippo

Hippos seem languid, listless, inert,
Lethargic...but do be alert.
They're really quite hostile,
And if you're in denial,
You could be lamentably hurt.

1. Score and cut the Hippo template on page 112, using the basic instructions provided on pages 8–10.

2. Fold along the scored lines, making the mountain and valley folds carefully. Pull up the eyes and open up the eyelids. Bring the ears up. Roll the muzzle, and push down the two upper front teeth (figure 1).

3. Insert the rolled muzzle pieces into the slits that you cut in the cheeks, next to the teeth. Connect these pieces behind the upper jaw by interlocking the tabs (figure 2).

4. Interlock the tabs on the lower jaw. Then from behind, roll the lower jaw against a dowel to round it some more (figure 3).

5. Work on the neck next. Shaping the neck involves three pocket folds (figure 4).

6. Move on to the body (figure 5).

7. Interlock the tabs on the belly (figure 6).

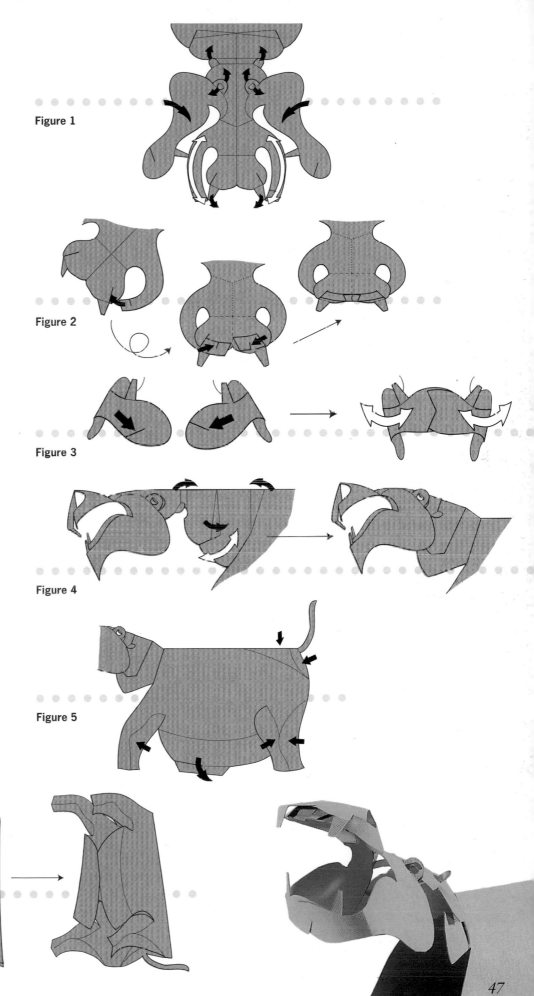

Figure 1

Figure 2

Figure 3

Figure 4

Figure 5

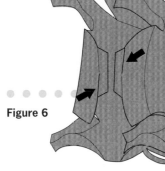

Figure 6

The Kangaroo Clan

Known for their pouches and their tails,
Found from Darwin to New South Wales…
Some learn to fight
In a ring. Not polite!
But the kangaroos always prevail.

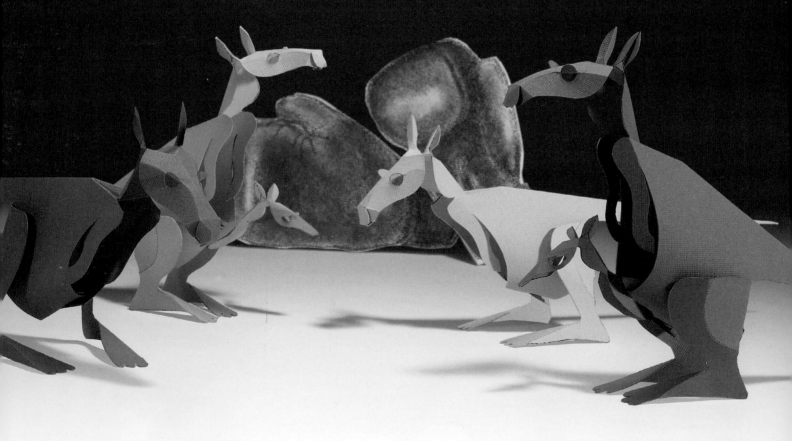

Father Kangaroo

1. Score and cut the Father Kangaroo template on page 111, using the basic instructions provided on pages 8–10.

2. Fold along the scored lines, making the mountain and valley folds carefully. Pull up the eyelids. Pinch the ears and make them stand up. Shape the muzzle (figure 1), and squeeze it to secure its shape. Push the center of the head down as you fold the body in half, all the way down to the tip of the tail.

3. Pocket-fold the neck into the shoulders (figure 2). Fold in the front legs, and shape them by rolling them on a dowel.

4. Roll the stomach to round it, and interlock the joint (figure 3).

5. Fold and shape the legs, and swing them forward (figure 4). Adjust the angles of the leg folds so the feet make good contact with the surface that they'll rest on.

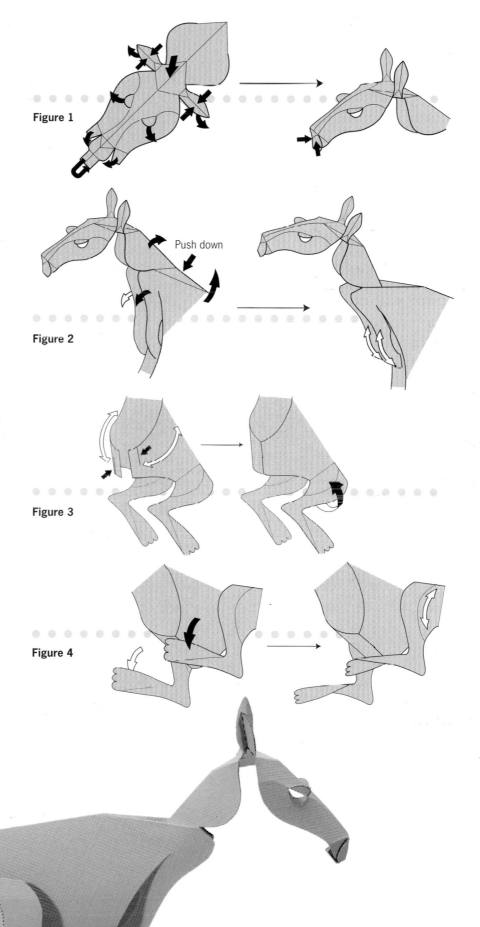

Figure 1

Figure 2

Push down

Figure 3

Figure 4

Mother Kangaroo and Joey

The Mother Kangaroo template on page 110 is identical to the one for the Father Kangaroo on page 111 except for the shape of her tail and her wider stomach opening (her pouch). To make her, use the instructions provided on page 49 for the Father Kangaroo.

To make the Baby Kangaroo, score and cut the Baby Kangaroo template on page 110. Shape its head the same as the adult heads, and make the folds in the body carefully. Then insert the baby into the mother's pouch and secure it in place by positioning the baby's front legs over her stomach (figure 5).

Figure 5

Gorillas bring to your attention,
They don't swat biplanes. So, never mention
"Me Tarzan, You Jane."
Or they'll complain
In the midst of their primate convention.

Gorilla

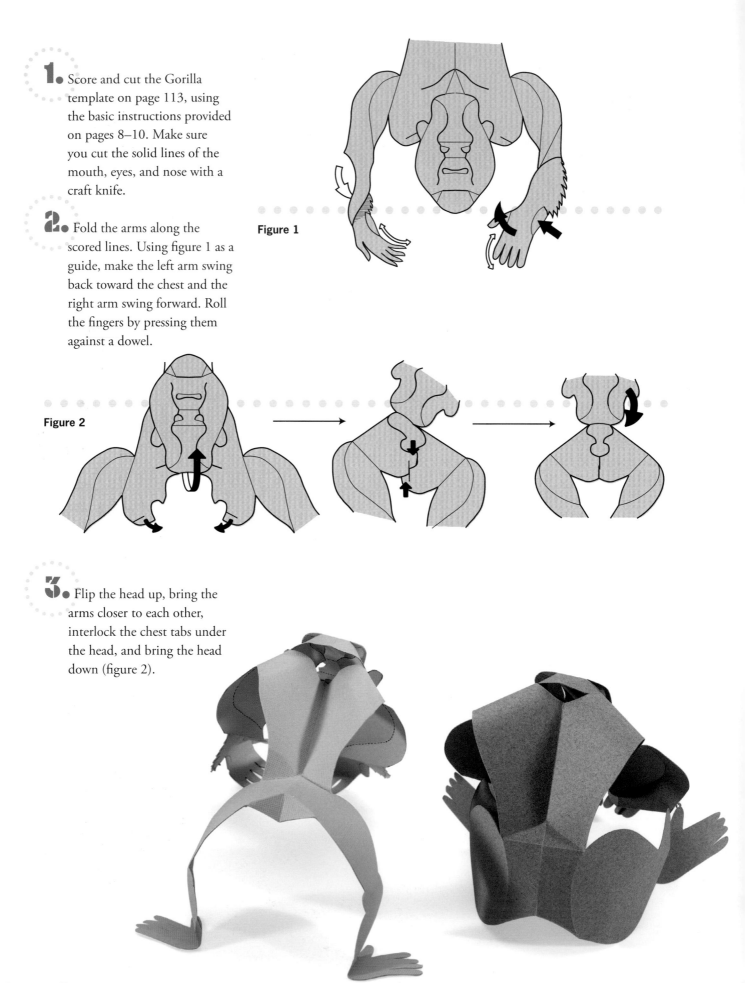

1. Score and cut the Gorilla template on page 113, using the basic instructions provided on pages 8–10. Make sure you cut the solid lines of the mouth, eyes, and nose with a craft knife.

2. Fold the arms along the scored lines. Using figure 1 as a guide, make the left arm swing back toward the chest and the right arm swing forward. Roll the fingers by pressing them against a dowel.

Figure 1

Figure 2

3. Flip the head up, bring the arms closer to each other, interlock the chest tabs under the head, and bring the head down (figure 2).

4. Work on the head next, referring to figure 3. Pull up the eyelids and ears, and push in the nose to open it. Push down the cheeks and roll them with a dowel to define the dimensional structure of the face from the forehead to the nose. Use a dowel to create the curve of the chin.

5. Round the back by pressing a dowel against its underside, and bring down the hip by pinching and squeezing the waist (figure 4).

6. Referring both to the photo on page 51 and to figure 5, shape the legs and round the toes slightly so that the feet rest comfortably on a flat surface.

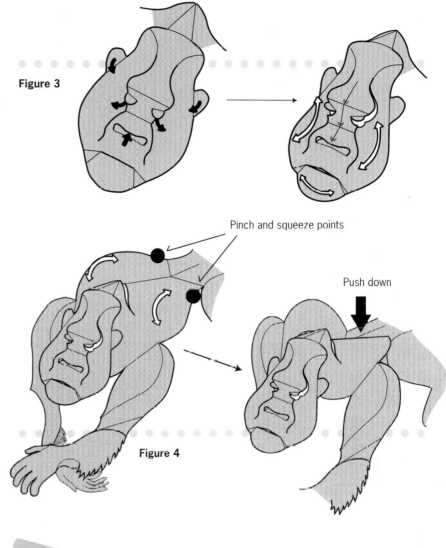

Figure 3

Pinch and squeeze points

Push down

Figure 4

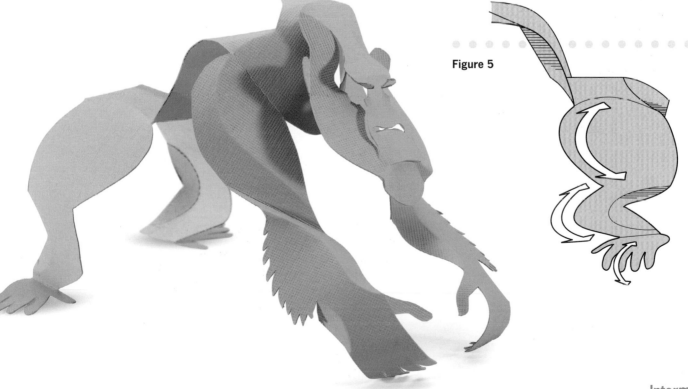

Figure 5

At top speed, an unquestioned world-beater.
Fourteen seconds in the 400-meter.
Great acceleration,
But on investigation…
It doesn't play fair; it's a cheetah!

Cheetah

1. Score and cut the Cheetah template on page 114, using the basic instructions provided on pages 8–10.

2. Shape the head and neck, following the scored lines. Fold in both cheeks behind the nose, and pocket-fold the shoulders over the neck (figure 1).

3. Referring to figure 2, push in the sides to create the arched back. Pocket-fold the tail into the hips, just as you folded the neck in step 2. Then fold the legs in half along the scored lines.

4. Align the two slits in the back of the hind legs, and insert the tips of the forelegs into them (figure 3).

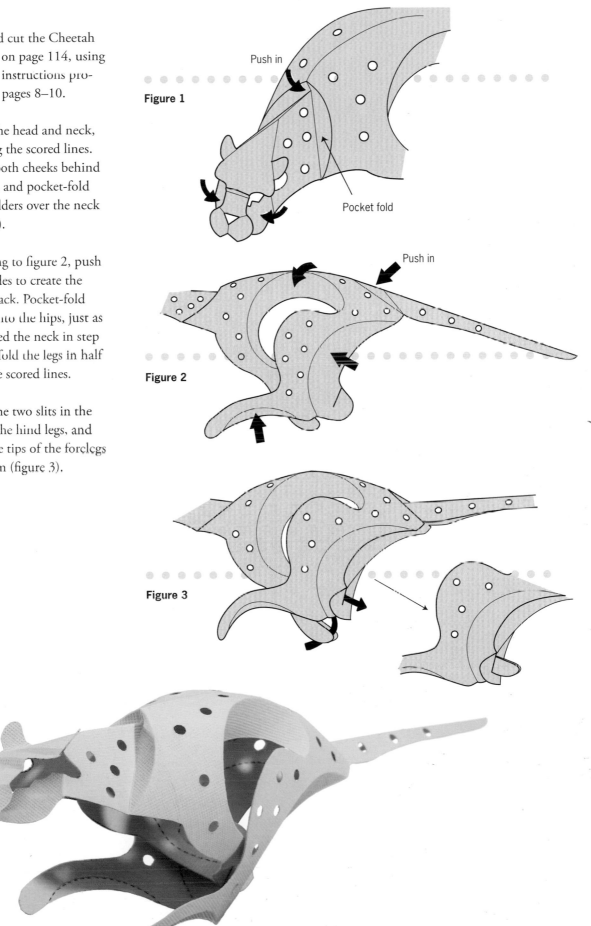

Push in

Figure 1

Pocket fold

Push in

Figure 2

Figure 3

Ostrich

Ostriches will nearly anything consume.
They are farmed for their lovely plumes.
Static electricity
Collects dust naturally,
Which assists them in cleaning their rooms.

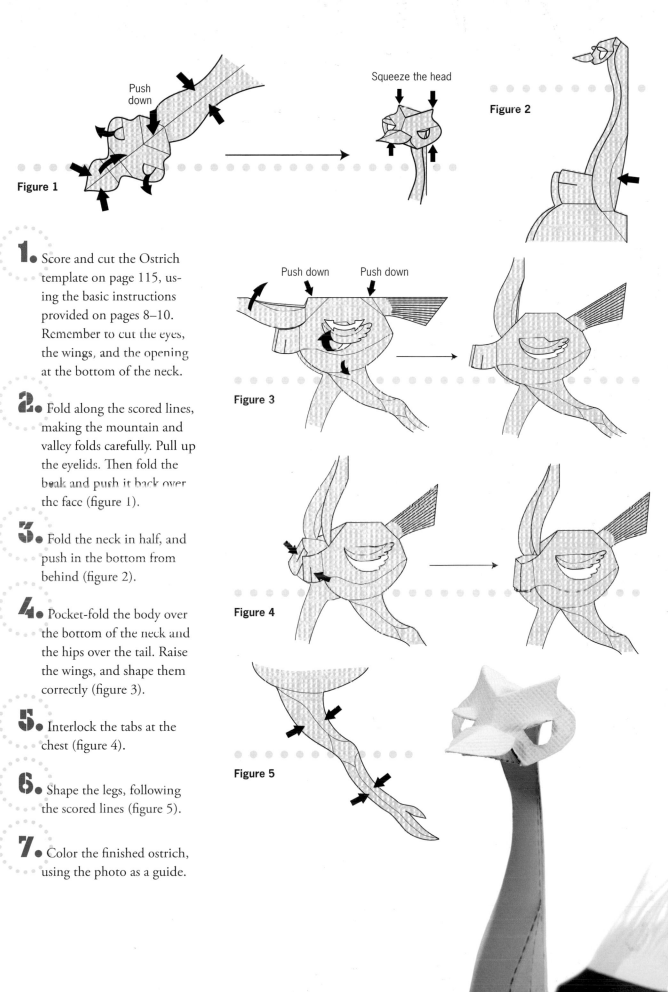

Push
down

Figure 1

Squeeze the head

Figure 2

Push down Push down

Figure 3

Figure 4

Figure 5

1. Score and cut the Ostrich template on page 115, using the basic instructions provided on pages 8–10. Remember to cut the eyes, the wings, and the opening at the bottom of the neck.

2. Fold along the scored lines, making the mountain and valley folds carefully. Pull up the eyelids. Then fold the beak and push it back over the face (figure 1).

3. Fold the neck in half, and push in the bottom from behind (figure 2).

4. Pocket-fold the body over the bottom of the neck and the hips over the tail. Raise the wings, and shape them correctly (figure 3).

5. Interlock the tabs at the chest (figure 4).

6. Shape the legs, following the scored lines (figure 5).

7. Color the finished ostrich, using the photo as a guide.

Owner's Manual for those with an elephant:
Be aware that they're very intelligent,
But stay out of their shoes
Or we'll bid you "adieu,"
And this guide will be rendered irrelevant.

The Elephant Herd

Mother and Father Elephant

1. Score and cut either pair of Elephant head and body templates on pages 116–118, using the basic instructions provided on pages 8–10.

2. Fold along the scored lines, making the mountain and valley folds carefully. Roll the top of the head with a dowel. Then, shape the center of the head (figure 1).

3. Shape the ears. Roll the flaps inside the ears against a dowel, and push them back toward the shoulders (figure 2).

4. Move on to the body. Pocket-fold the bottom of the neck into the shoulders as you fold the body in half along the centerline (figure 3).

5. Shape the legs and the tail next (figure 4).

6. Interlock the tabs at the belly (figure 5).

Tip

You can use these instructions to make either the Father or Mother Elephant; their designs are almost identical. The only differences are the scales of their bodies and the shapes of their tusks.

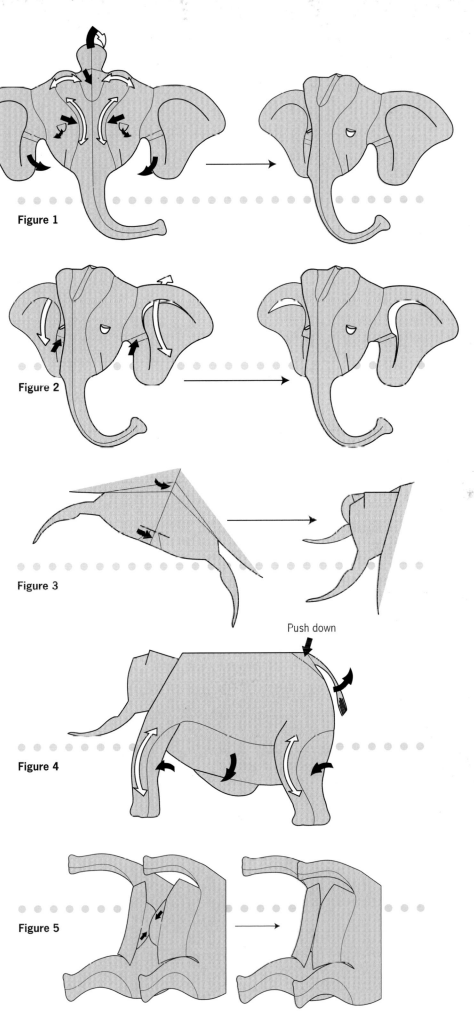

Figure 1

Figure 2

Figure 3

Push down

Figure 4

Figure 5

7. Connect the head and body by inserting the tusks into the slits in the cheeks and the tab at the back of the head into the slit at the top of the neck (figure 6).

8. Let the notches in the tusks catch the top end of the slits. Then, shape the tusks as you like (figure 7).

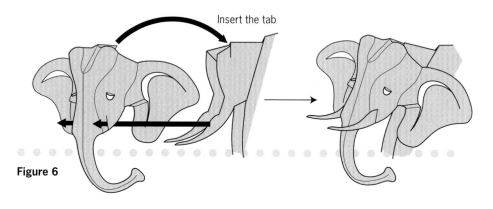

Insert the tab

Figure 6

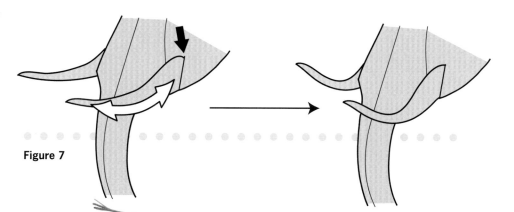

Figure 7

Baby Elephant

1. Score and cut the Baby Elephant template on page 118, following the basic instructions provided on pages 8–10.

2. Fold along the scored lines, making the mountain and valley folds carefully (figure 1).

3. Pull the eyelids up to open the eyes, and roll back the V-shaped sections inside the ears (figure 2).

4. Interlock the tabs at the bottom of the body (figure 3).

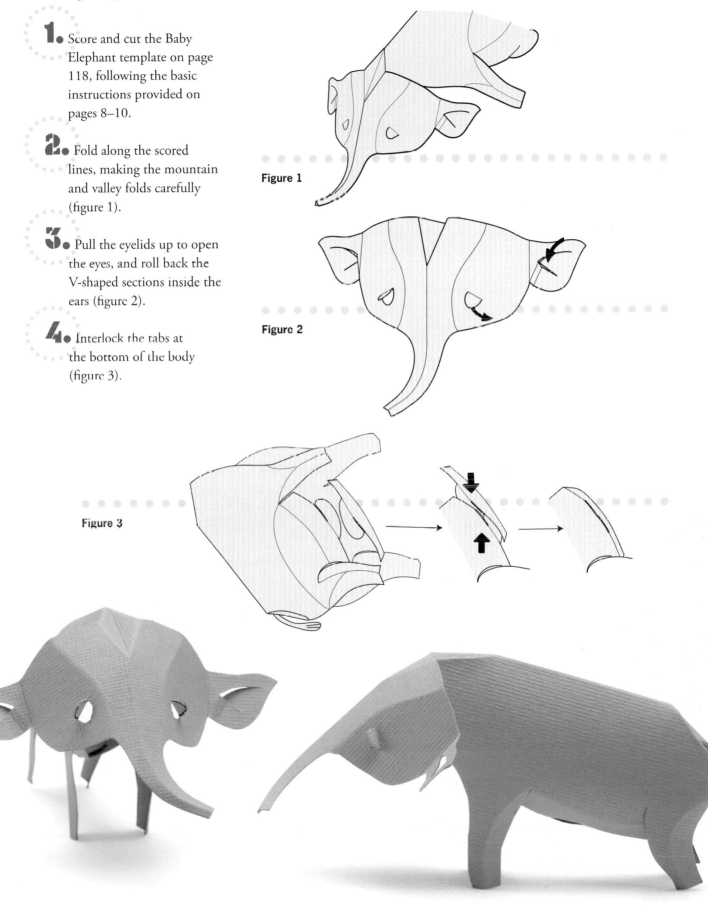

Figure 1

Figure 2

Figure 3

Owl

Around the world owls abound,
From the tundra to holes in the ground.
They look so astute,
Although, when they hoot
One expects something far more profound.

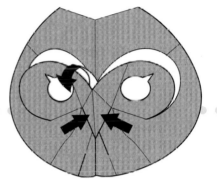

1. Score and cut the Owl template on page 101, using the basic instructions provided on pages 8–10. Remember to cut the eyes, the beak, and the lines of the feathers in the wings.

2. Fold along the scored lines, making the mountain and valley folds carefully. Pull out the eyes, and pinch the beak so that it extends outward from the face (figure 1).

3. Interlock the tabs on the jaw (figure 2).

4. Shape the wings, using figure 3 and the photo as guides.

Figure 1

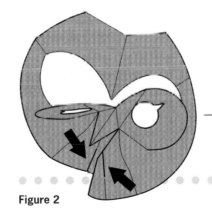

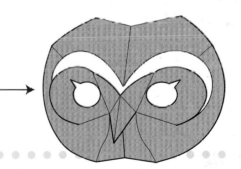

Figure 2

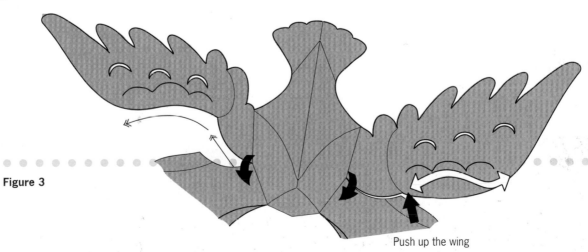

Figure 3

Push up the wing

5. Shape the body and legs next, as shown in figure 4.

6. Interlock the tabs at the chest (figure 5).

7. Shape the tail (figure 6).

8. To display your finished Owl as if it were flying, pierce the X shape marked on the template with a needle. Then run a length of thread through the hole, and suspend the Owl by the thread.

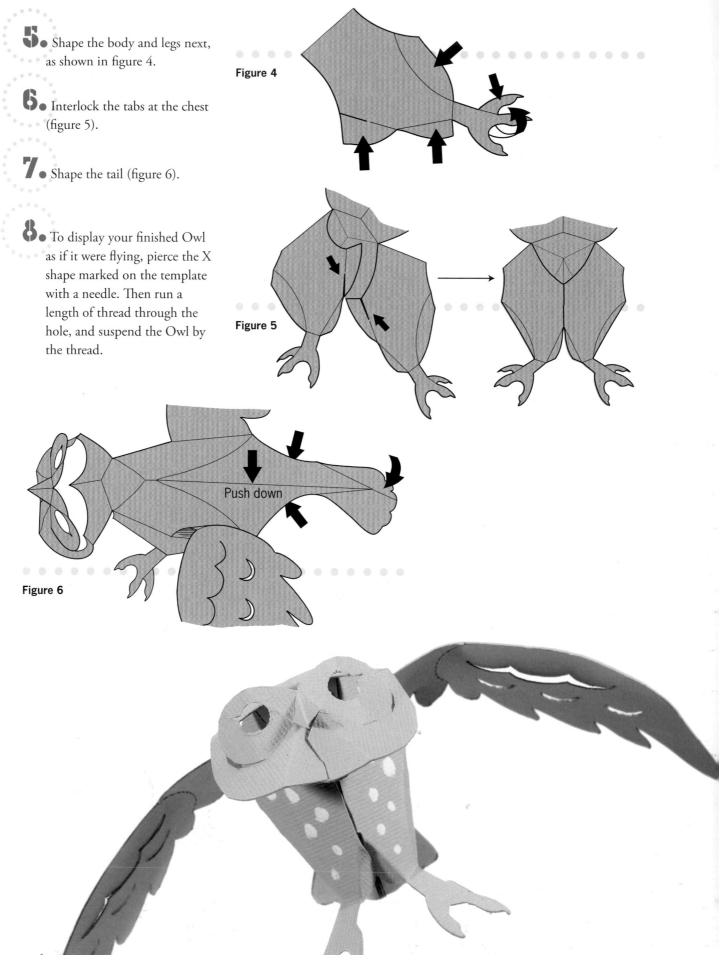

Figure 4

Figure 5

Push down

Figure 6

The alligator (known for its smile)
Is distinct from its kin, the crocodile.
You may wear gator suits,
Purses, wallets, and boots,
While crocs are far less versatile.

Alligator

1. Score and cut the Alligator body and tail templates on page 119, using the basic instructions provided on pages 8–10. Remember to cut the eyelids, nostrils, and the scales on the back and tail.

2. Fold along the scored lines, making the mountain and valley folds carefully. Pull the eyelids out. Push down the nose and the flap behind the eyes (figure 1).

3. Form the lower jaw by bringing the two sections together and interlocking the tabs (figure 2).

4. Roll the neck pieces behind the lower jaw over a dowel, and interlock the tabs (figure 3).

5. Move on to the body. Raise the scales on the back as you fold the template along the scored lines (figure 4).

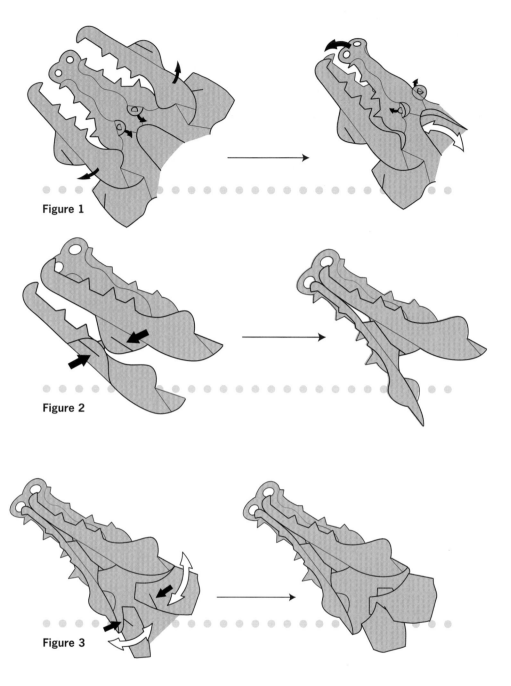

Figure 1

Figure 2

Figure 3

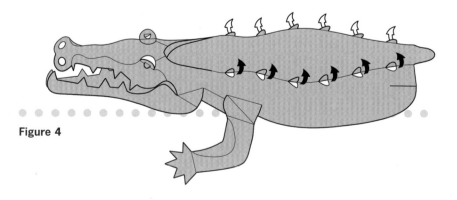

Figure 4

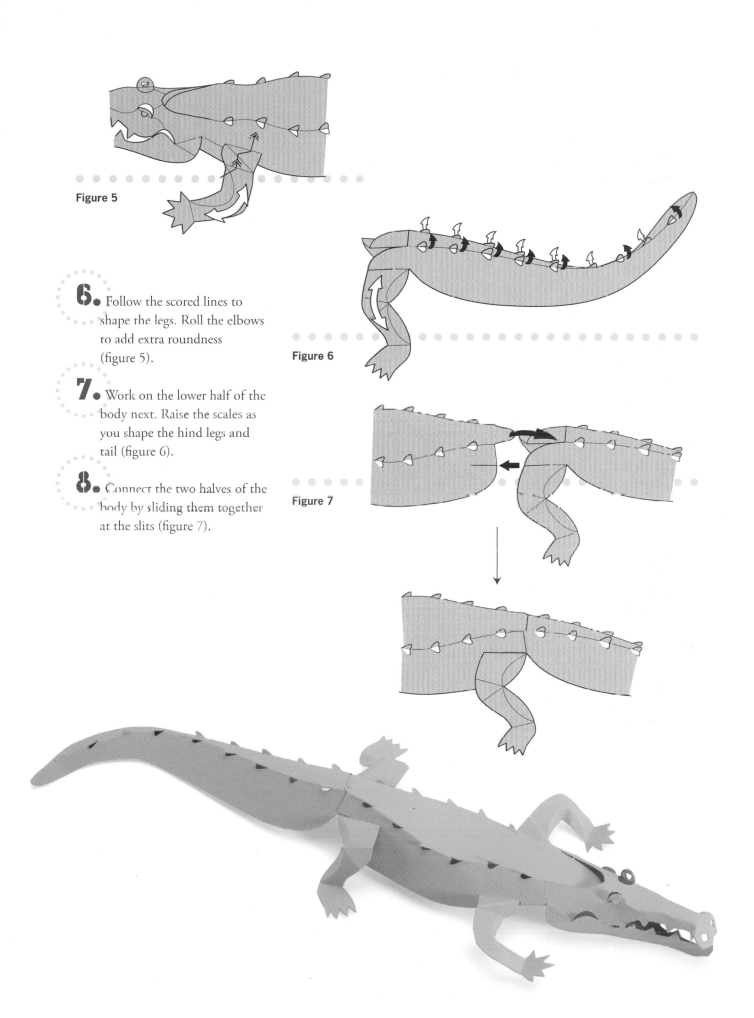

Figure 5

6. Follow the scored lines to shape the legs. Roll the elbows to add extra roundness (figure 5).

7. Work on the lower half of the body next. Raise the scales as you shape the hind legs and tail (figure 6).

8. Connect the two halves of the body by sliding them together at the slits (figure 7).

Figure 6

Figure 7

Cardinal

If cardinal friends are your intent,
Sunflower seeds will make them content.
For life, a cardinal mates,
The state bird of seven states,
Which, for the record, is fourteen percent.

1. Score and cut the Cardinal template on page 105, using the basic instructions provided on pages 8–10.

2. Fold along the scored lines, making the mountain and valley folds carefully.

3. Push the wings down onto the sides and interlock the tabs on the back of the bird (figure 1).

4. Interlock the tabs near the feet, at the bottom (figure 2).

5. Finish the assembly by shaping the beak (figure 3).

Tip

If you'd like to color your cardinal, after you've scored and cut the template (see step 1), use black to fill in the areas shown in figure 4 on the template-printed surface. Then paint the beak red on the outside. Your finished Cardinal will look like the one in the photo below.

Figure 1

Figure 2

Figure 3

Figure 4

No cat in the world asks permission.
None show mercy or ambition.
Nor responsibility.
Nor a shred of humility.
But we love them… it's tradition.

Cat.

1. Score and cut the Cat template on page 98, using the basic instructions provided on pages 8–10. Make sure you cut the solid lines of the mouth, eyes, and nose with a craft knife.

2. Fold along the scored lines. Then interlock the tabs at the top of the cat's head (figure 1).

3. Interlock the tabs behind the tail (figure 2).

4. Flip up the head. Fold over the left front leg, and slide it under the corner of the head (figure 3).

5. Create the arched back by pressing the paper against a dowel. Curve the legs and the tail in the same manner (figure 4).

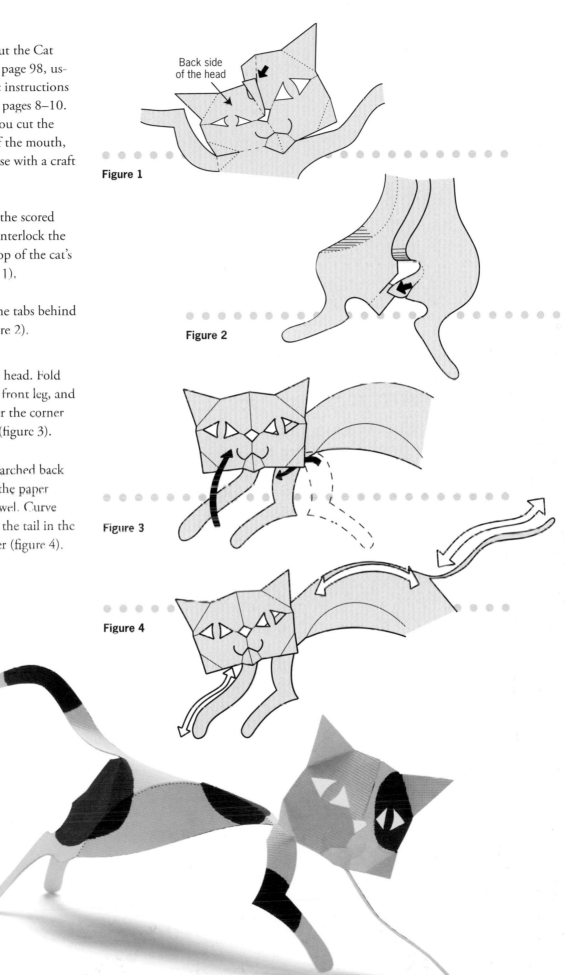

Back side of the head

Figure 1

Figure 2

Figure 3

Figure 4

Armadillos are interesting, let's bet.
They don't really make good pets.
But they're easy to name
'Cause they all look the same,
For each litter is matching quadruplets.

Armadillo

1. Score and cut out the Armadillo template on page 120, using the basic instructions provided on pages 8–10. The eyes can be cut out easily with a paper (or leather) punch.

2. Fold along the scored lines, making the mountain and valley folds carefully. Pinch the ears and pull them up. Push down the center of the neck by squeezing the shoulders (figure 1). Then turn the head of the Armadillo slightly downward.

3. Work on the body next. Following the scored lines, fold the armored back (figure 2).

4. Without flattening the mountain and valley folds you've already made, fold the whole torso in half along the centerline. Then insert the four leg tabs into the slits in the bellows (figure 3).

5. Shape the tail following the scored lines, and fold it in half (figure 4). Then push down the root of the tail where it's connected to the hips.

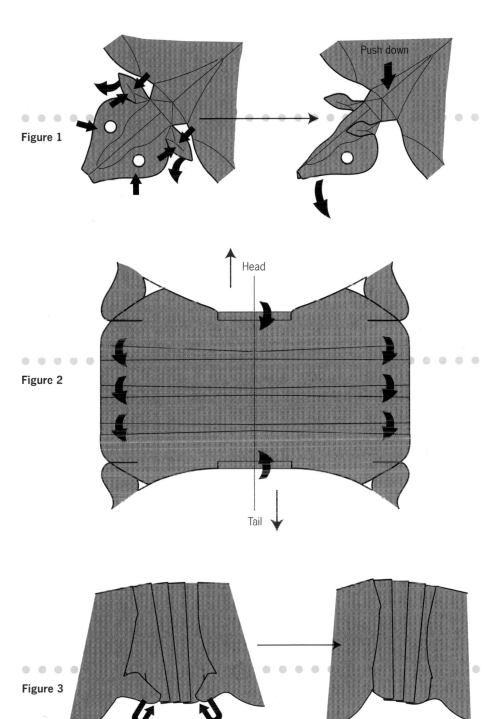

Push down

Figure 1

Head

Figure 2

Tail

Figure 3

Push down

Figure 4

6. Now work on the legs. Make sure you squeeze the folded legs firmly so the Armadillo will stand up well (figure 5).

7. If you have trouble making the tabs stay in the bellow slits, try folding in the bottom of the body (figure 6).

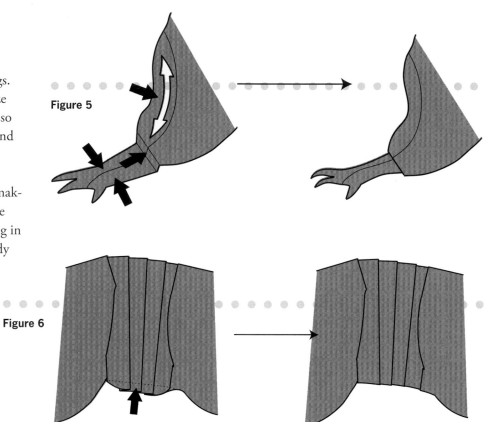

Figure 5

Figure 6

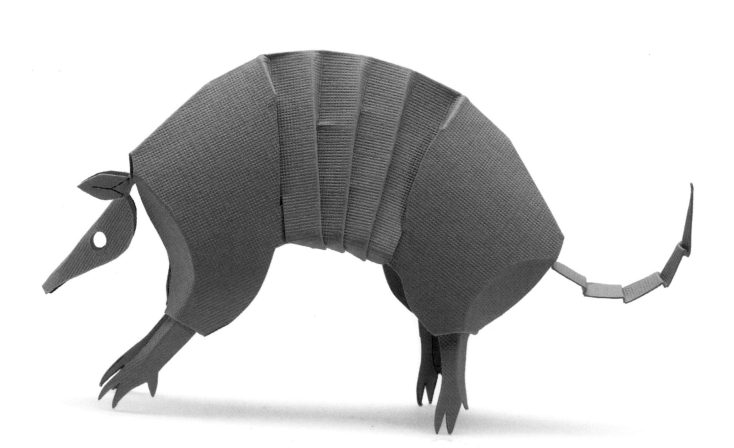

Chimpanzee

Chimpanzees are quite territorial,
Can use tools, and are arboreal.
Their memories, it's acknowledged,
Better than students in college.
We'll refrain from comments editorial.

1. Score and cut the Chimpanzee template on page 121, using the basic instructions provided on pages 8–10. Remember to cut the eyes, the opening for the nose, and the lines inside the ears and mouth.

2. Fold along the scored lines, making the mountain and valley folds carefully. Pull up the eyelids, and push back the insides of the ears. Insert a small dowel between the face and the cheeks, and roll it against the cheeks (figure 1). Then lift the upper lip.

3. Roll the top of the head against a dowel, and interlock the joint (figure 2).

4. Fold down the small tabs at the sides of the neck, and tuck them behind the head (figure 3).

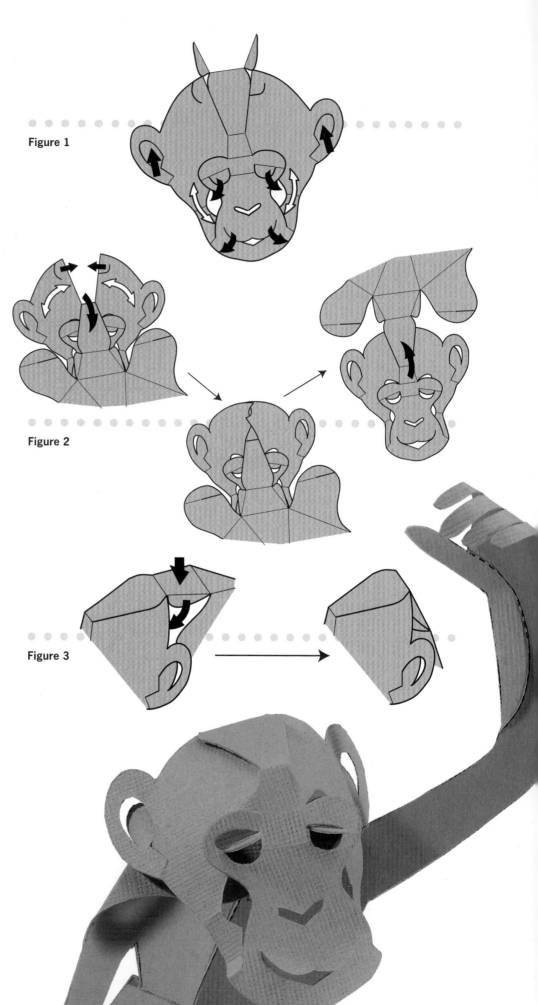

Figure 1

Figure 2

Figure 3

5. Move on to the body. Fold the torso along the scored lines. Then interlock the chest joint (figure 4).

6. Shape the arms and the legs (figure 5).

7. Shape the hands and feet by rolling the fingers and toes against a dowel to make them look as if they're ready to grip something (figure 6).

Figure 4

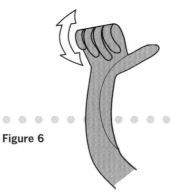

Tip

You can display your Chimpanzee by hanging it from a paper tree, as shown in the photo on page 75, or you can make more than one chimpanzee, and suspend them by joining the hands of one to the feet of another.

Figure 5

Figure 6

Crab

Pity the crab! Some reasons include:
It's boiled and served up as food.
Its many legs shattered,
Dipped in butter or batter
'Till its name coincides with its mood.

1. Score and cut the Crab template on page 124, using the basic instructions provided on pages 8–10.

Figure 1

2. Fold along the scored lines, making the mountain and valley folds carefully. Fold all eight legs in half along their scored centerlines. Moving from the root to the tip, pocket-fold both joints on each leg (figure 1).

Push down

Figure 2

3. Shape the belly (figure 2).

4. Work on the claws next (figure 3).

Figure 3

5. Interlock the tabs on the back (figure 4).

6. Flip over the lower half of the body, and insert the tab between the eyes into the slit at the top of the shell (figure 5).

Figure 4

Figure 5

Push down

Figure 6

7. Roll up the eyes. Push down the nose. Bend the tip of the tab down to secure the connection (figure 6).

8. Adjust the angles of the legs so that only their tips touch the surface on which the crab will rest.

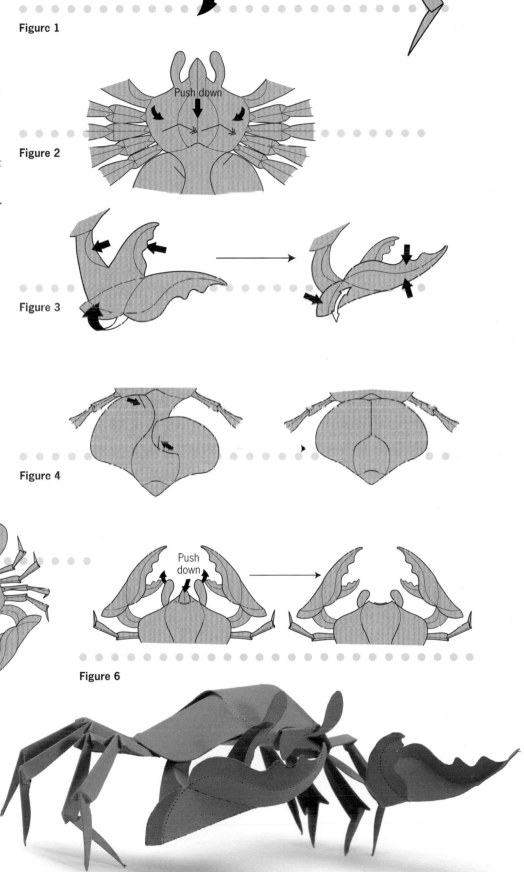

Rhino

The rhino plies its horn in defense,
Protected by armor so immense.
Though its mood seems sour,
It gives birds rides for hours.
But, that might be a coincidence.

1. Score and cut the Rhino template on page 123, using the basic instructions provided on pages 8–10. Remember to cut the eyes, the nostrils, and the two openings in the head through which the horns will fit.

2. Fold along the scored lines, making the mountain and valley folds carefully. Start working on the head by rolling the muzzle and the eyes against a dowel and shaping the ears by pinching them and pulling them up (figure 1).

3. Turn the template over. Pinch the large horn, and insert it into the triangular opening above the nose (figure 2).

4. Referring to figure 3, bring the two pieces of the small horn toward the center of the head, and run them through the slit between the eyes. Hook the notch in the small horn over the edge of the slit.

5. Pull up the eyelids, spread the large horn slightly to help it stay securely in the opening of the head, and pinch the muzzle a little so that it holds its shape well (figure 4).

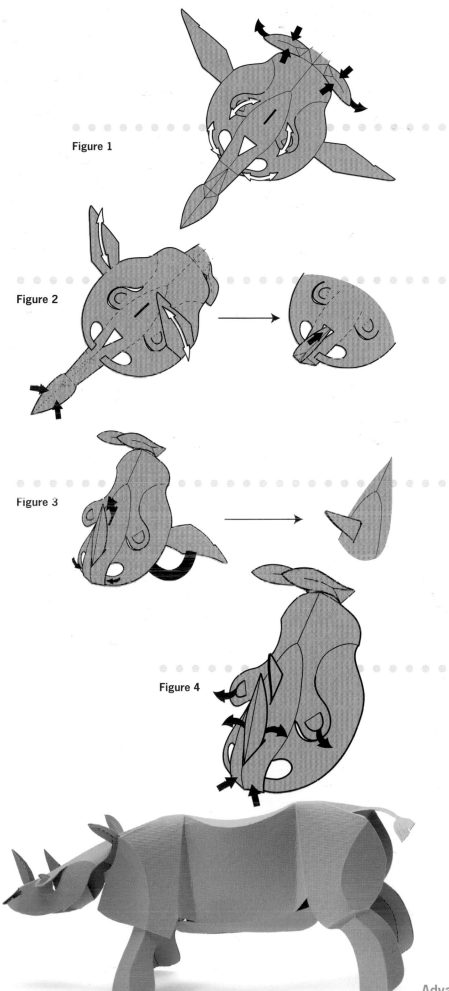

Figure 1

Figure 2

Figure 3

Figure 4

6. Move on to the body. Roll the underside of the belly with a dowel, push down the back, and shape the folds of the surface correctly, using figure 5 as a guide.

7. Interlock the chest tabs (figure 6).

8. Interlock the tabs on the belly (figure 7).

9. Push the head down to create a better posture, and squeeze the tops of the legs firmly to make the rhino stand up straight (figure 8).

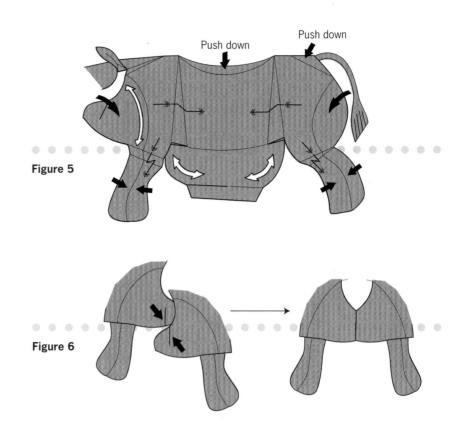

Push down Push down

Figure 5

Figure 6

Figure 7

Figure 8

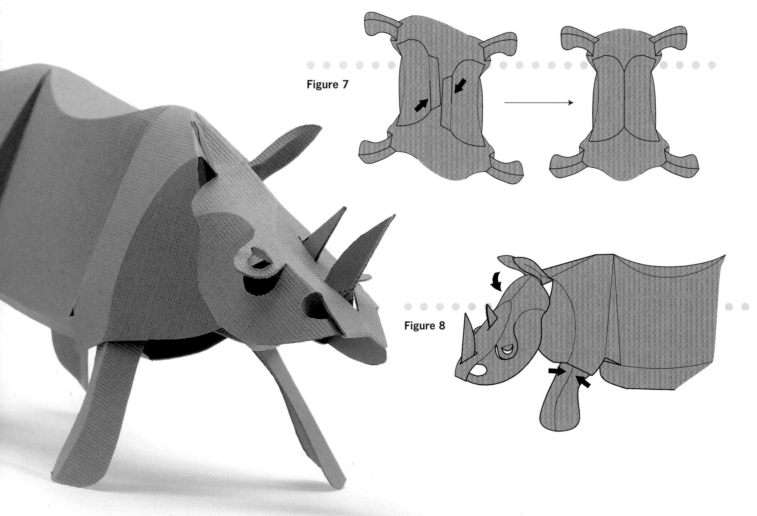

Tiger

While in camouflage undetectable,
The tiger stalks prey most delectable.
We mortals are terrified,
So no one has verified
If the stripes on each side are symmetrical.

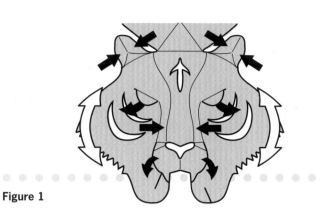

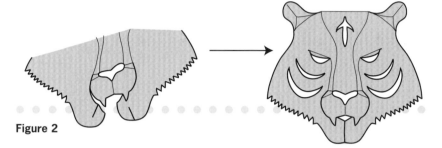

Figure 1

Figure 2

1. Score and cut the Tiger template on page 122, using the basic instructions provided on pages 8–10. Make all the interior cuts first; then work on the outline.

2. Fold along the scored lines, making the mountain and valley folds carefully. Then start working on the head by rolling the cheeks against a dowel. Squeeze in the sides of the nose to make it protrude from the cheeks. Pull up the eyelids. Pinch the ears and make them stand up.

3. Interlock the tabs on the lower jaw (figure 2).

4. Move on to the body. Push down the back, as well as the root of the tail. The body of the Tiger isn't symmetrical, so use figures 3 and 4 as a guide when folding each side.

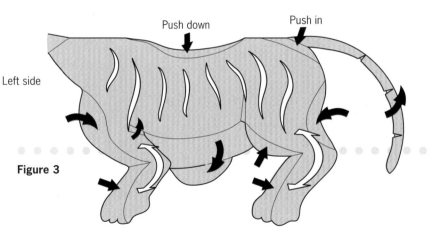

Push down Push in

Left side

Figure 3

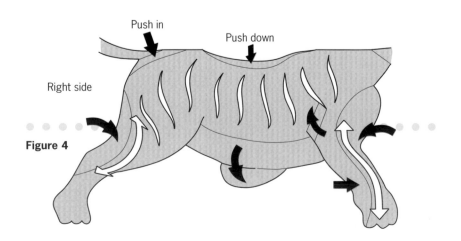

Push in Push down

Right side

Figure 4

5. Interlock the belly tabs.

6. Make two or more photocopies of the Bamboo template on page 103. Score and cut each stalk.

7. Shape the leaves and the stalks, making the mountain and valley folds carefully (figure 6).

8. Use a dowel to roll the two stalks into half cylinder shapes. Then fasten the halves together with adhesive tape or glue (figure 7). (Note: This is the only time that this book requires adhesives!)

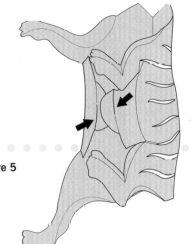

Figure 5

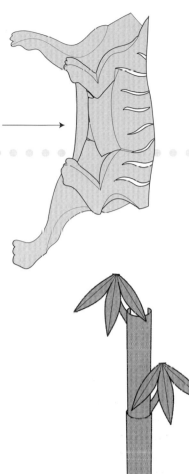

Insert
and
Connect

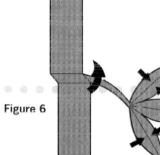

Figure 6

Figure 7

Perched high atop a barn or a shed
Crows the rooster, but have we been misled?
Early risers we praise
As they greet the sun's rays
But perhaps they're just going to bed.

Rooster

1. Using the basic instructions provided on pages 8–10, score and cut the Rooster template on page 125, including the solid lines of the beak and the wattle. Punch out the eyes with a craft knife or a paper punch.

2. If you want to color your Rooster, now is the best time. Color the comb and the wattle red, on the front of the template (the side on which the folding lines don't show), and color the tail feathers on the back of the template (figure 1).

3. Fold the template in half along the scored centerline. Then fold over and lift the top half of the body (figure 2).

4. Using figure 3 as a guide, push the comb down into the opening in the forehead, and pull out the beak and the wattle. (These are all pocket-folds.)

5. Interlock the flaps around the neck, behind the head (figure 4).

6. Shape the wings, pull them up, and hook the notches in them onto the indents on the back of the chest (figure 5).

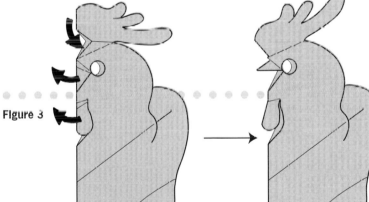

Figure 1

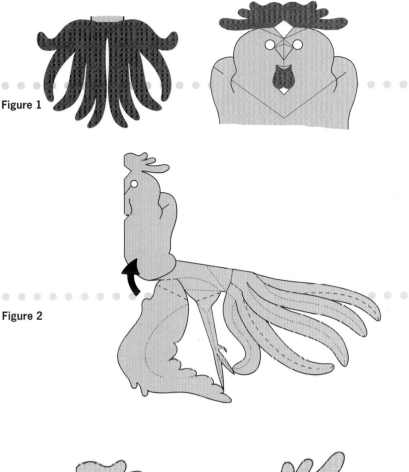

Figure 2

Figure 3

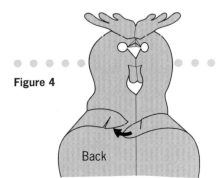

Figure 4

Back

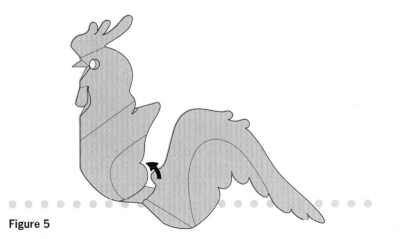

Figure 5

7. Open up the tail feathers. Fold each in half along its centerline; then fold the first and second outside tail feathers over toward the center (figure 6).

8. Pull the tail feathers up, turning them inside out (figure 7).

9. Referring to figure 8, shape the legs, following the folding lines. Roll the toes; and then bend the legs at the middle to create the joints.

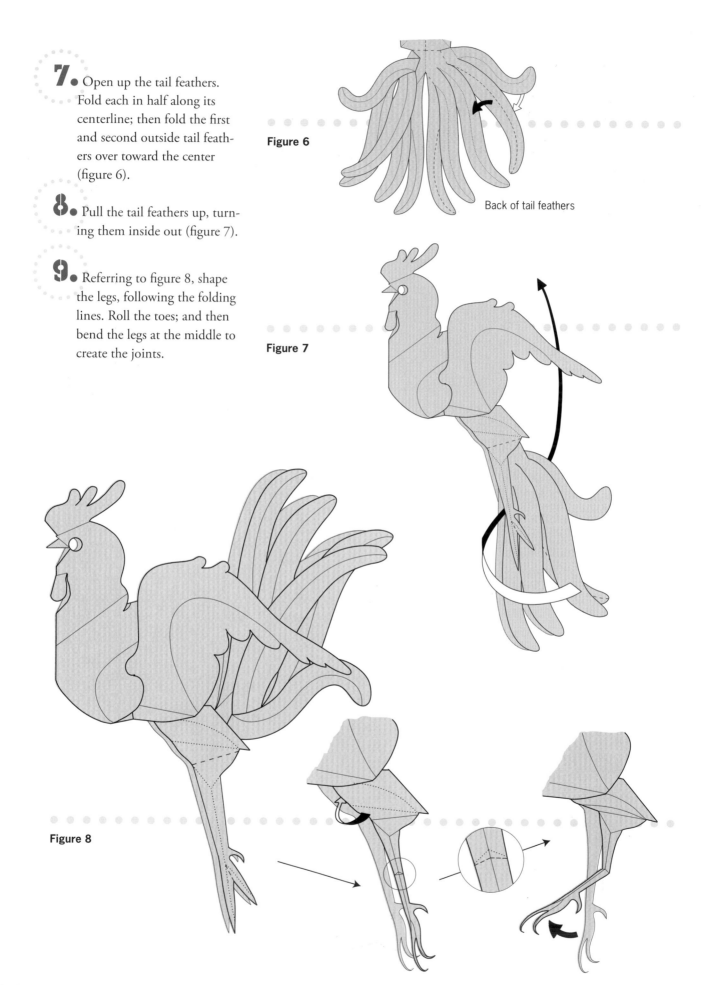

Figure 6

Back of tail feathers

Figure 7

Figure 8

Tip

A simple display stand is easy to create (figure 9). Insert a thin metal wire into a wooden base, and bend the wire at the top to support the Rooster. Make the stand high enough to keep the Rooster's feet suspended above the wooden base to convey the sense that the Rooster is hopping.

Figure 9

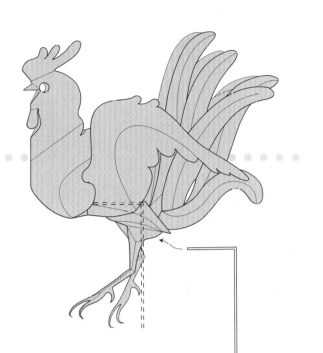

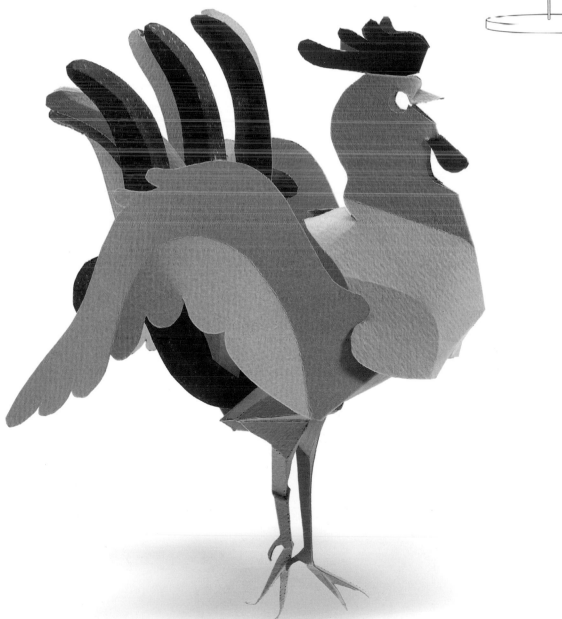

Zebra

The zebra is not seen everyday,
Except in the alphabet and this cliché:
"It's black stripes on white...
Or light on dark, right?"
Or wildly contrasting shades of plain gray.

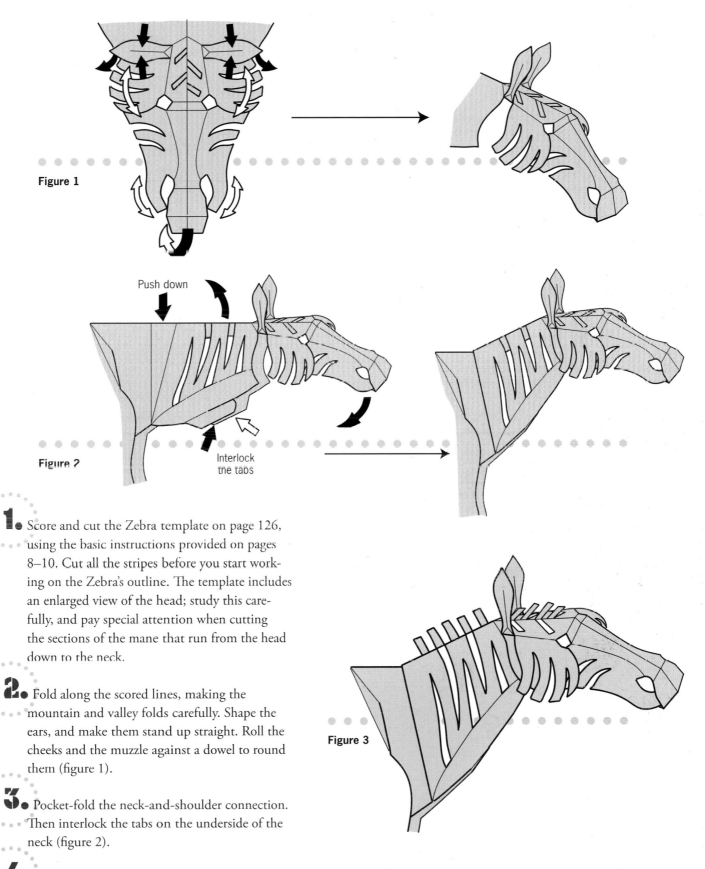

Figure 1

Push down

Interlock
the tabs

Figure 2

Figure 3

1. Score and cut the Zebra template on page 126, using the basic instructions provided on pages 8–10. Cut all the stripes before you start working on the Zebra's outline. The template includes an enlarged view of the head; study this carefully, and pay special attention when cutting the sections of the mane that run from the head down to the neck.

2. Fold along the scored lines, making the mountain and valley folds carefully. Shape the ears, and make them stand up straight. Roll the cheeks and the muzzle against a dowel to round them (figure 1).

3. Pocket-fold the neck-and-shoulder connection. Then interlock the tabs on the underside of the neck (figure 2).

4. Fold the sections of the mane from the head down to the neck to make them stand up (figure 3).

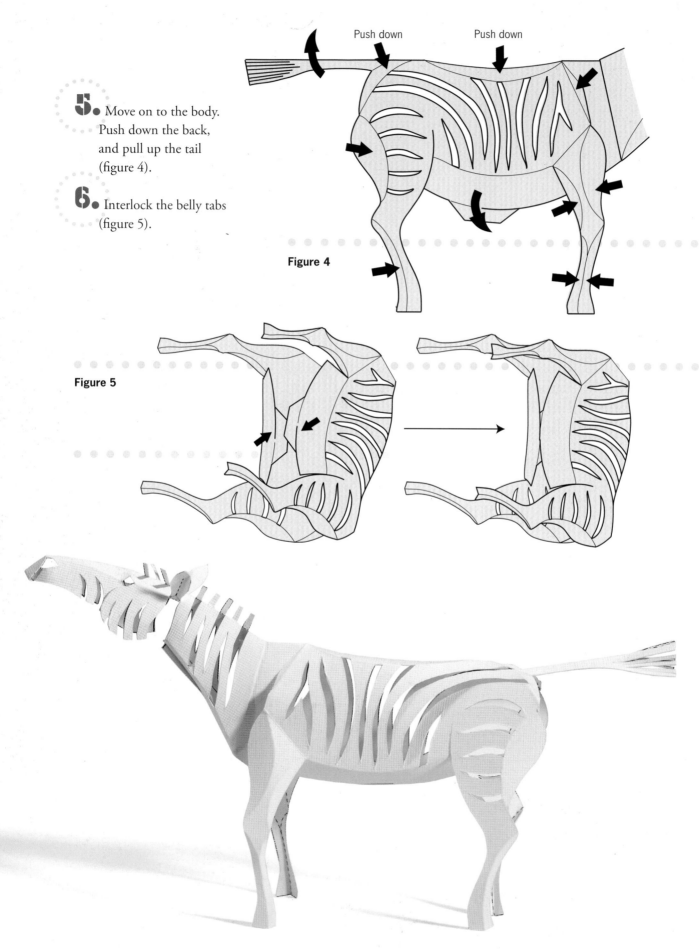

5. Move on to the body. Push down the back, and pull up the tail (figure 4).

6. Interlock the belly tabs (figure 5).

Push down Push down

Figure 4

Figure 5

Dragon

Fire-breathing and shrouded in vapor,
The dragon's strong limbs seem to taper
To razor sharp nails
That guard shimmering scales.
Aren't you glad it's just made of paper?

Tip

Making this Dragon involves very small, delicate cuts with a craft knife. If you're a young child or uncomfortable handling a knife, you'll definitely want to ask someone more skilled to score and cut for you.

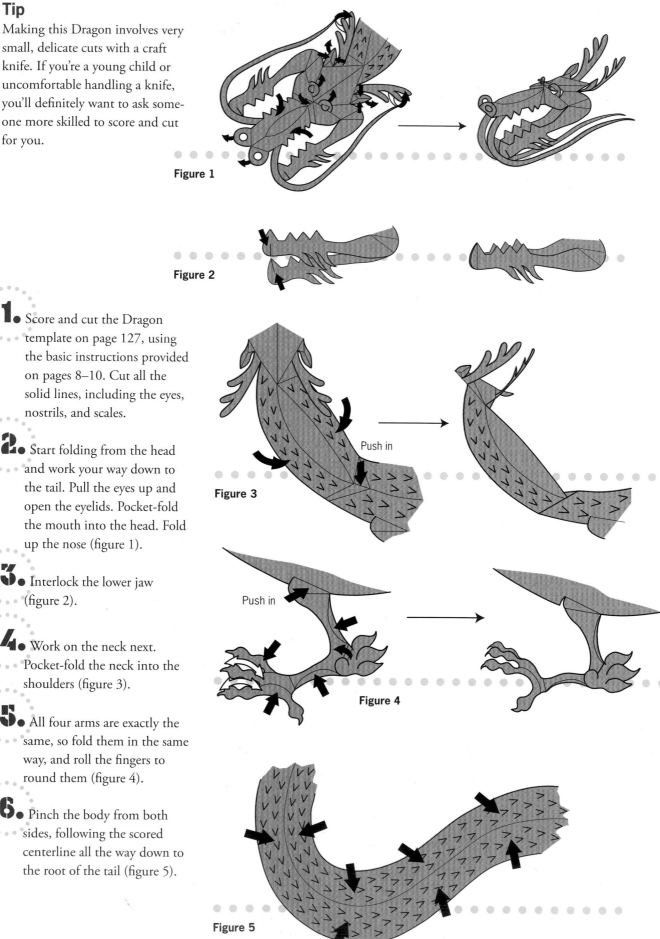

Figure 1

Figure 2

1. Score and cut the Dragon template on page 127, using the basic instructions provided on pages 8–10. Cut all the solid lines, including the eyes, nostrils, and scales.

2. Start folding from the head and work your way down to the tail. Pull the eyes up and open the eyelids. Pocket-fold the mouth into the head. Fold up the nose (figure 1).

3. Interlock the lower jaw (figure 2).

4. Work on the neck next. Pocket-fold the neck into the shoulders (figure 3).

5. All four arms are exactly the same, so fold them in the same way, and roll the fingers to round them (figure 4).

6. Pinch the body from both sides, following the scored centerline all the way down to the root of the tail (figure 5).

Push in

Figure 3

Push in

Figure 4

Figure 5

7. Shape the tail (figure 6).

8. Roll the whiskers into wavy curves (figure 7).

9. Working your way toward the tail, raise the scales of the body by pushing them out from underneath with an awl (figure 8).

10. To display your finished dragon as if it were flying, pierce the tip of the diamond shape at the top of the neck (it's marked with an X on the template) with a needle. Then run thread through the hole, and suspend the dragon from the thread (figure 9).

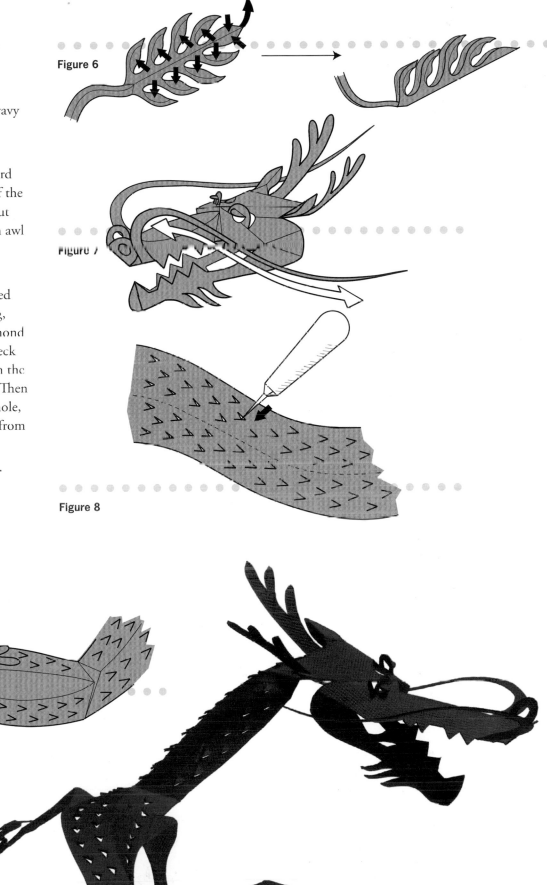

Figure 6

Figure 7

Figure 8

Figure 9

Templates

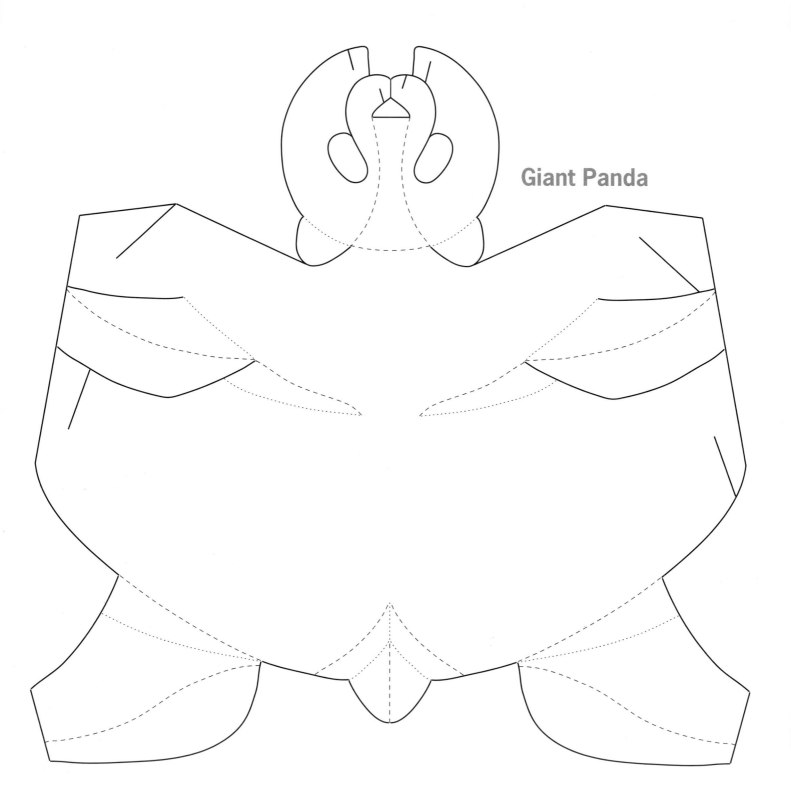

Giant Panda

Rabbit

Sheep

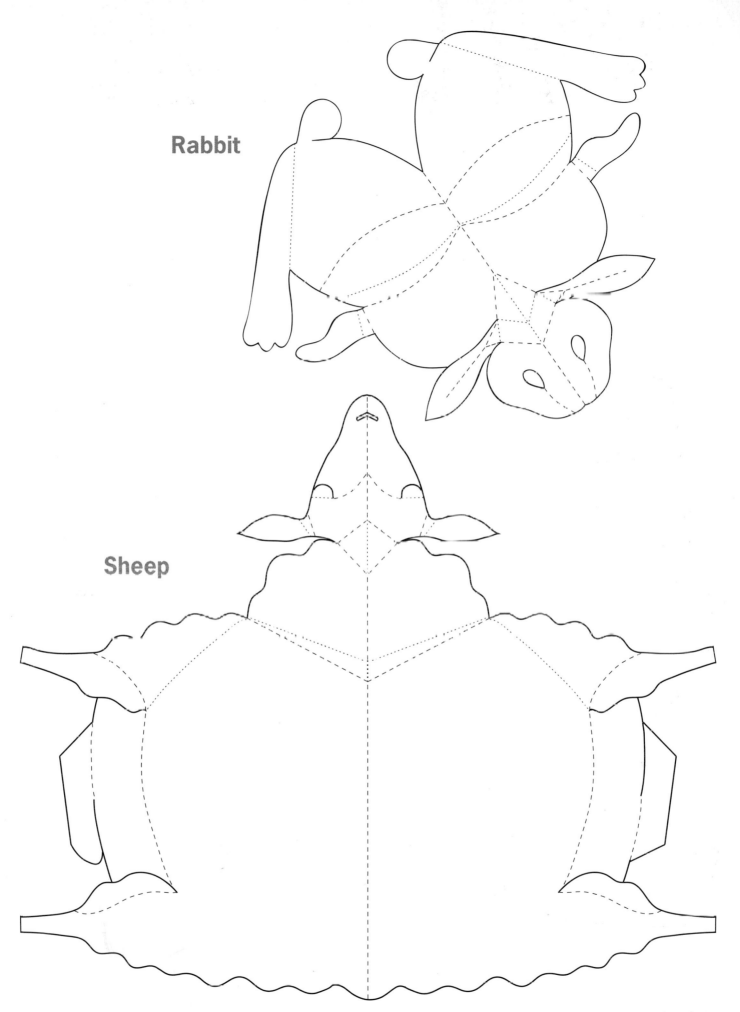

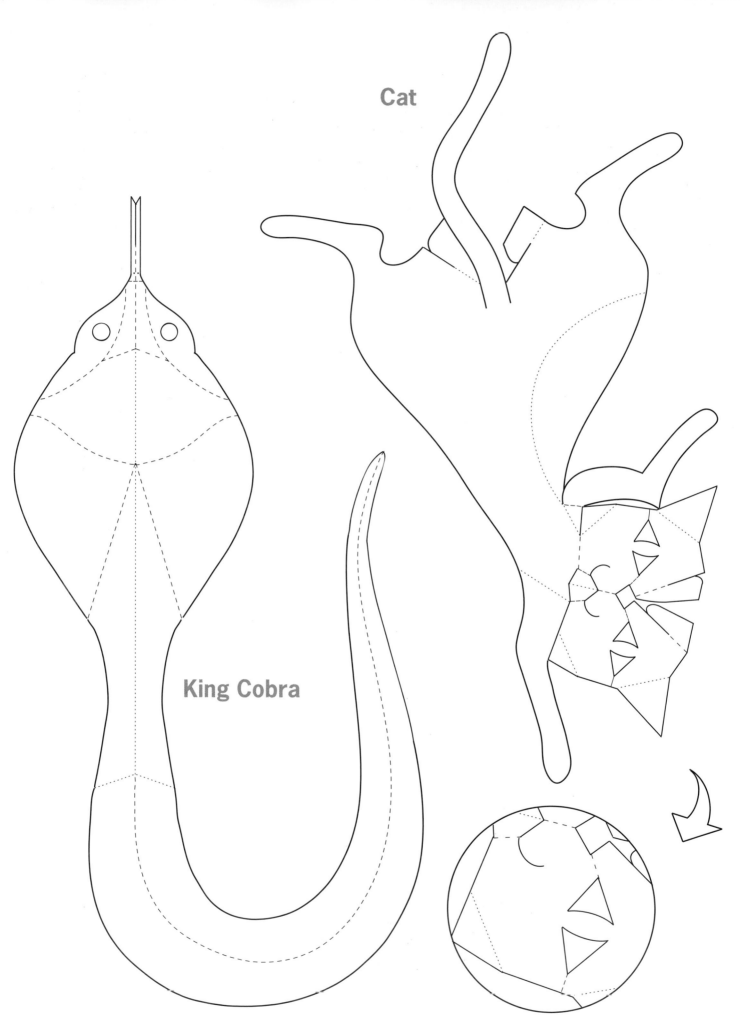

Cat

King Cobra

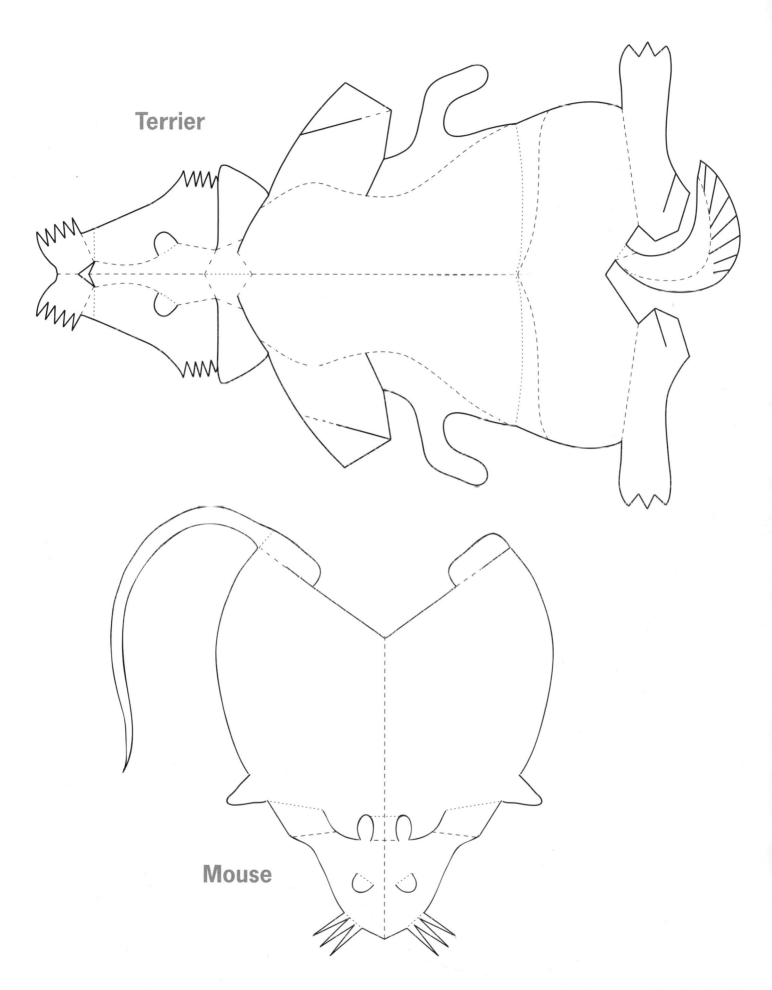

Terrier

Mouse

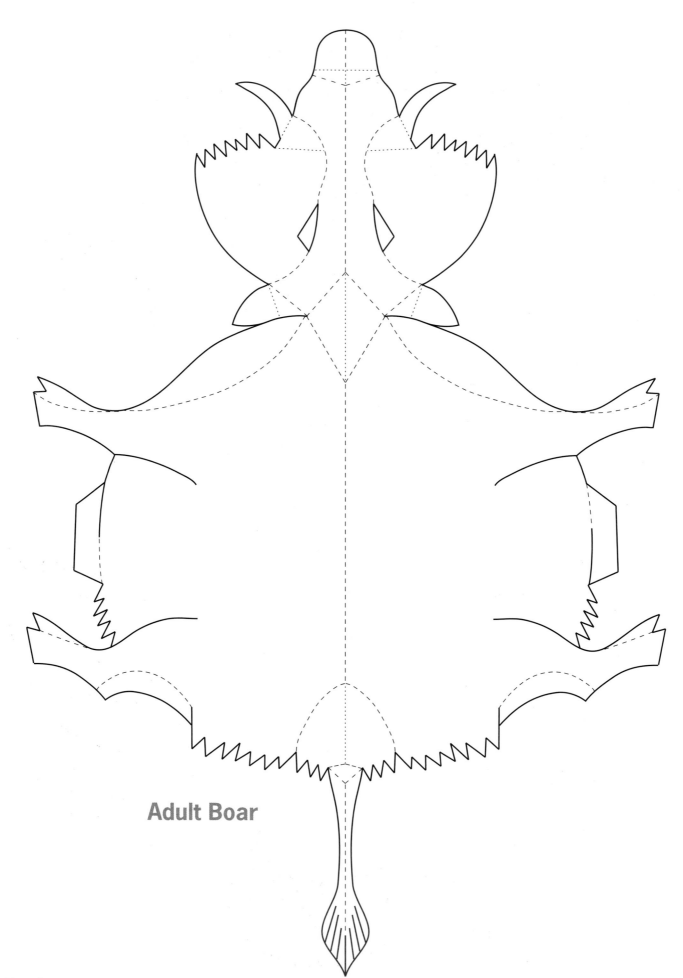

Adult Boar

Baby Boar

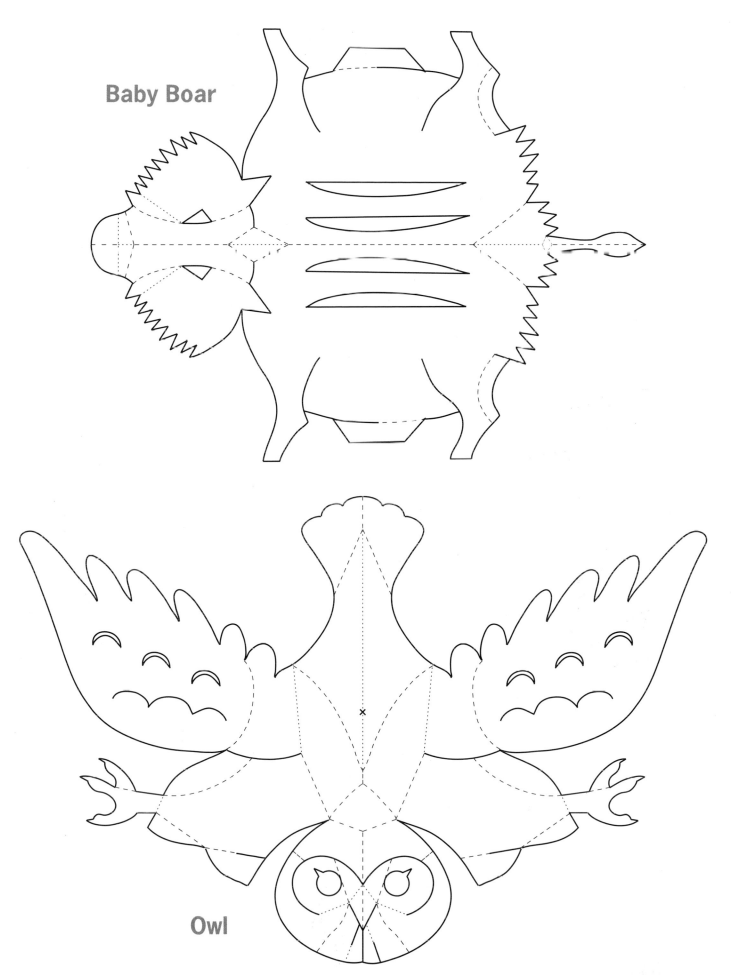

Owl

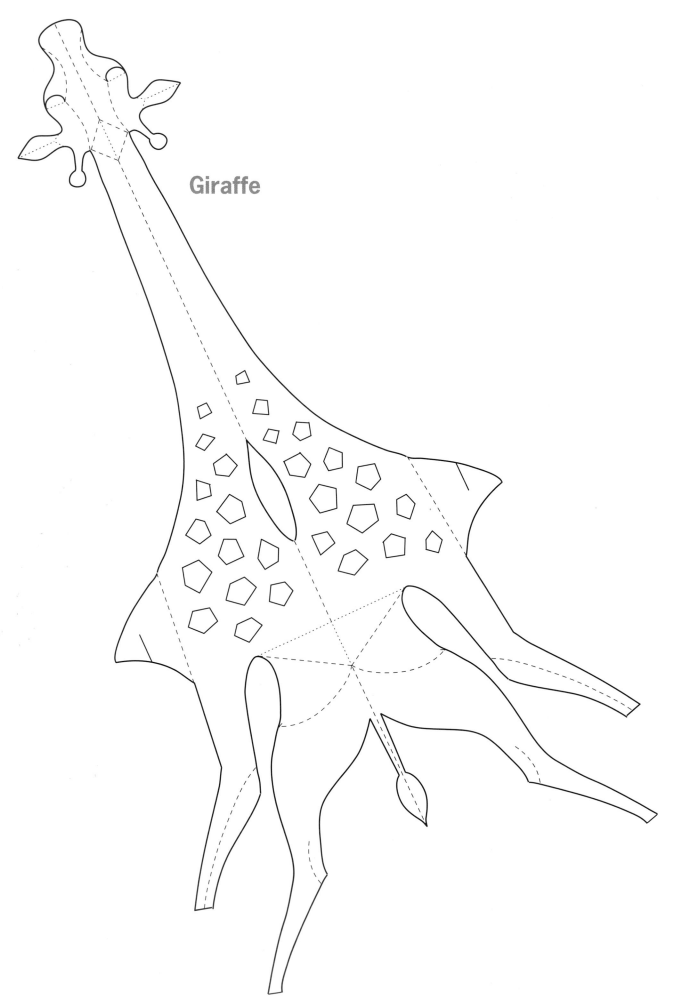

Giraffe

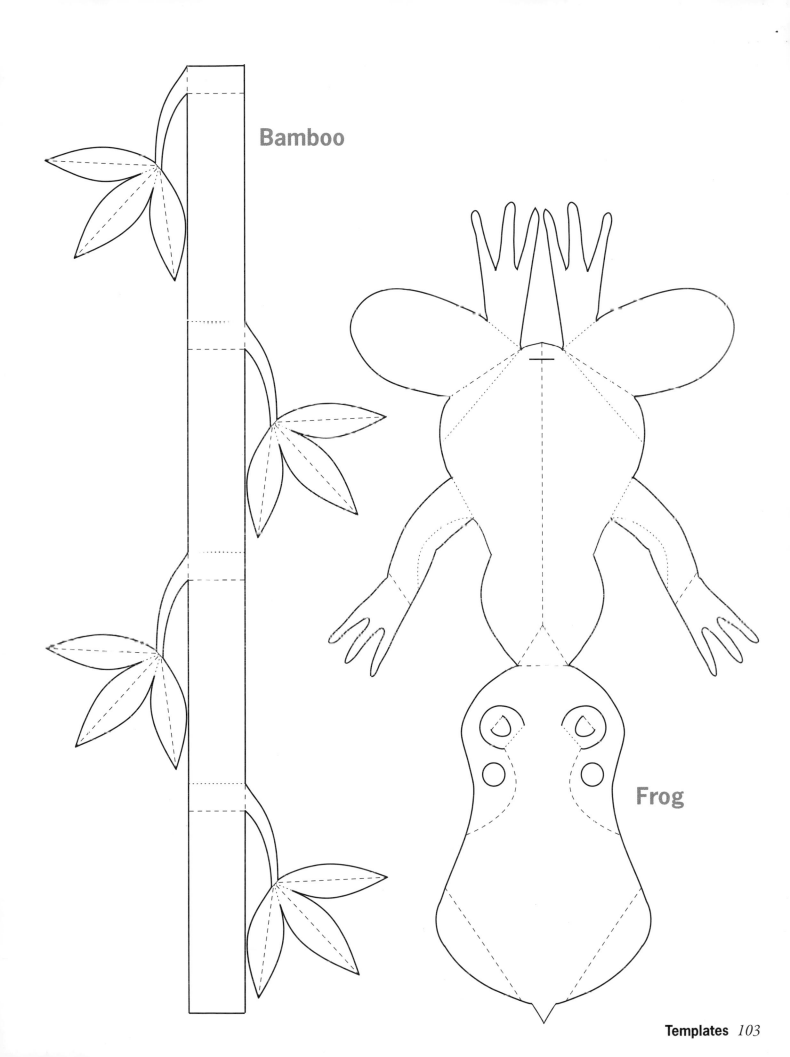

Bamboo

Frog

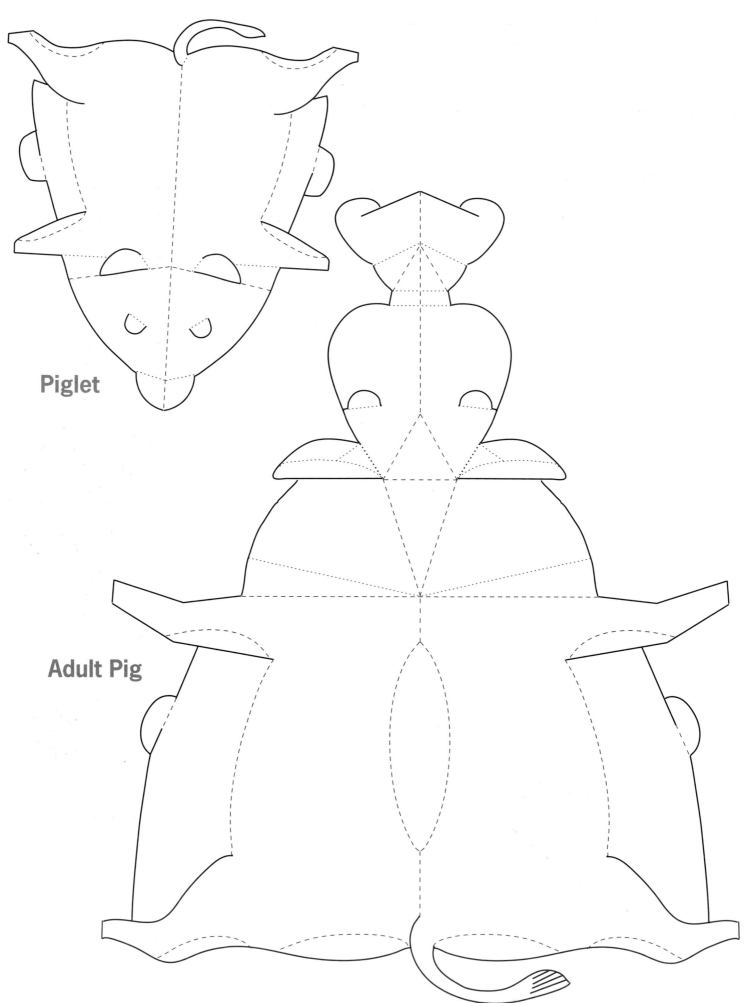

Piglet

Adult Pig

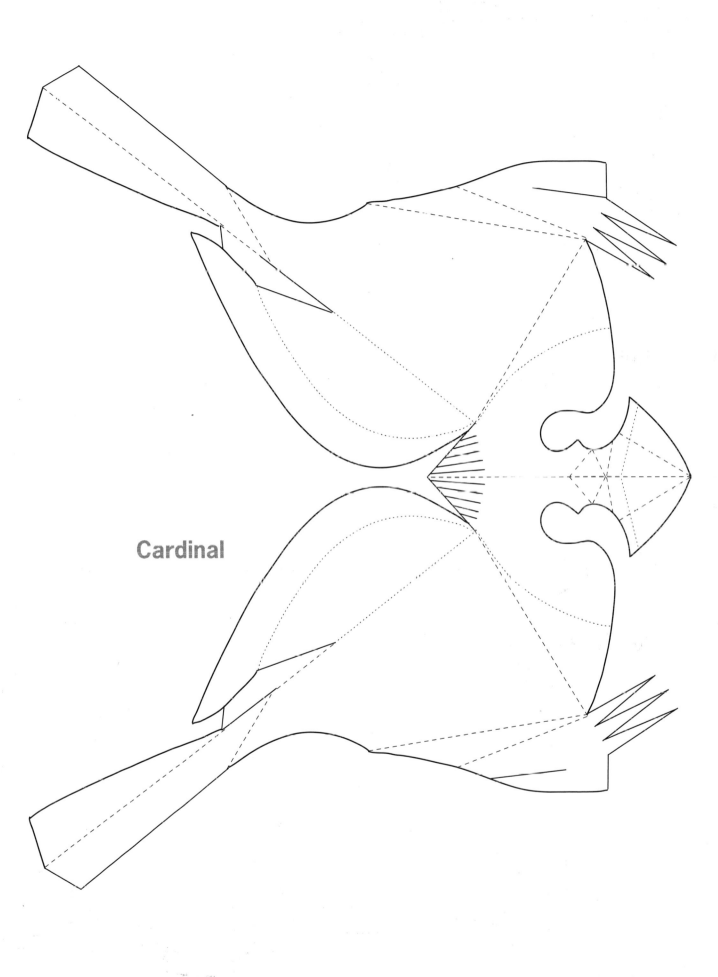

Cardinal

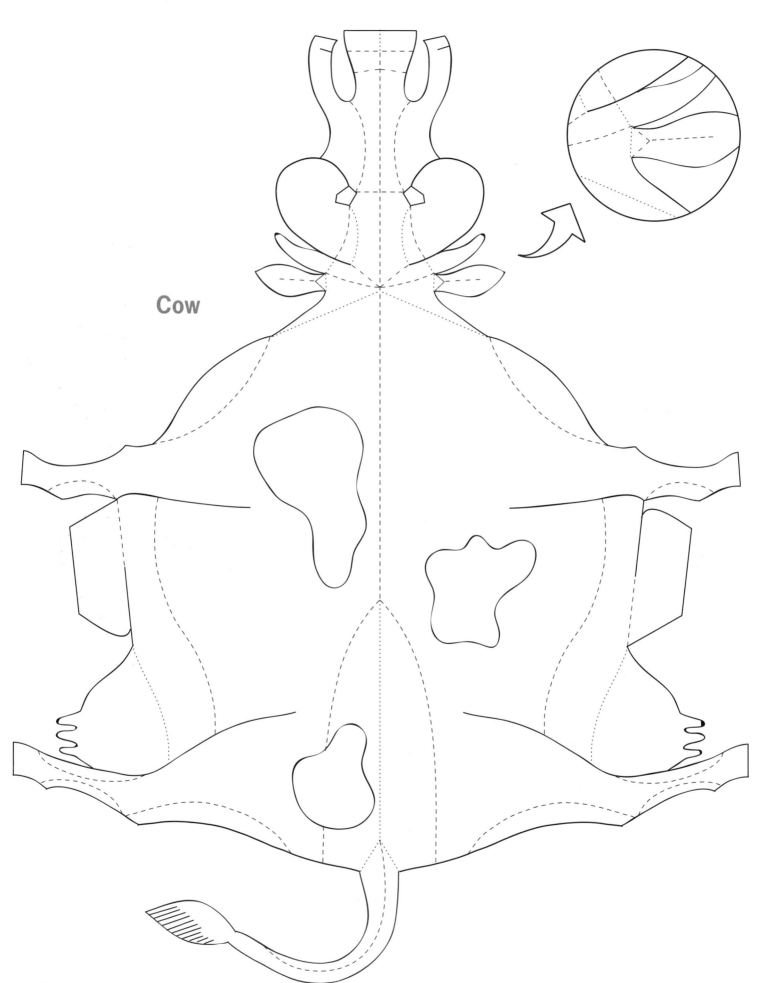

Cow

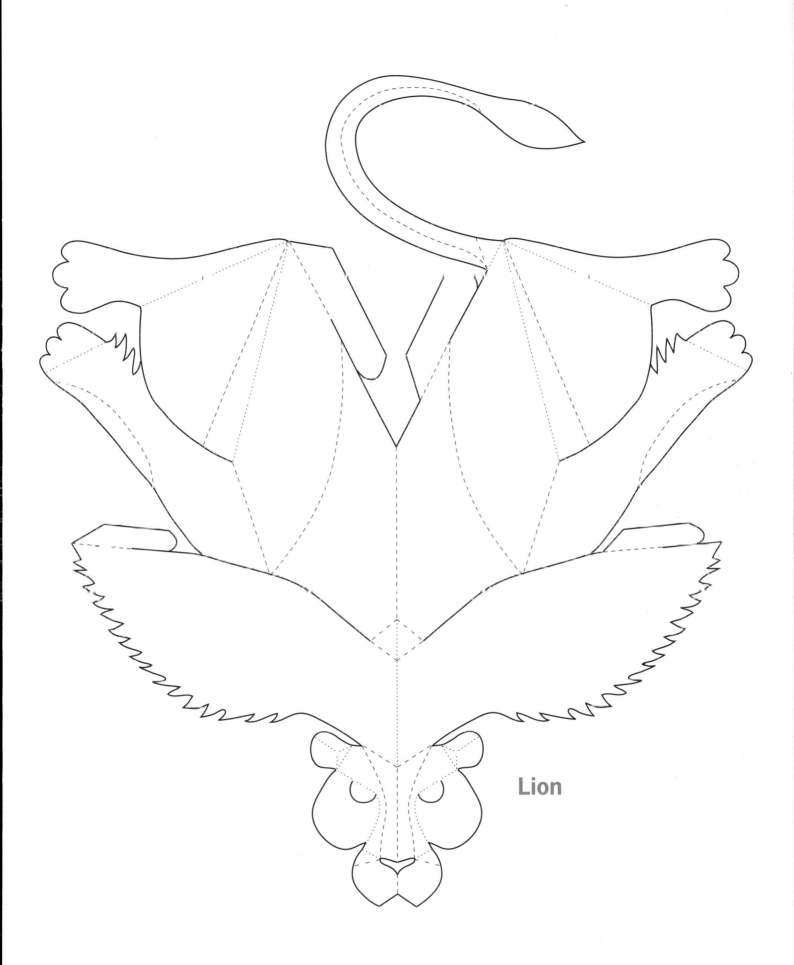

Lion

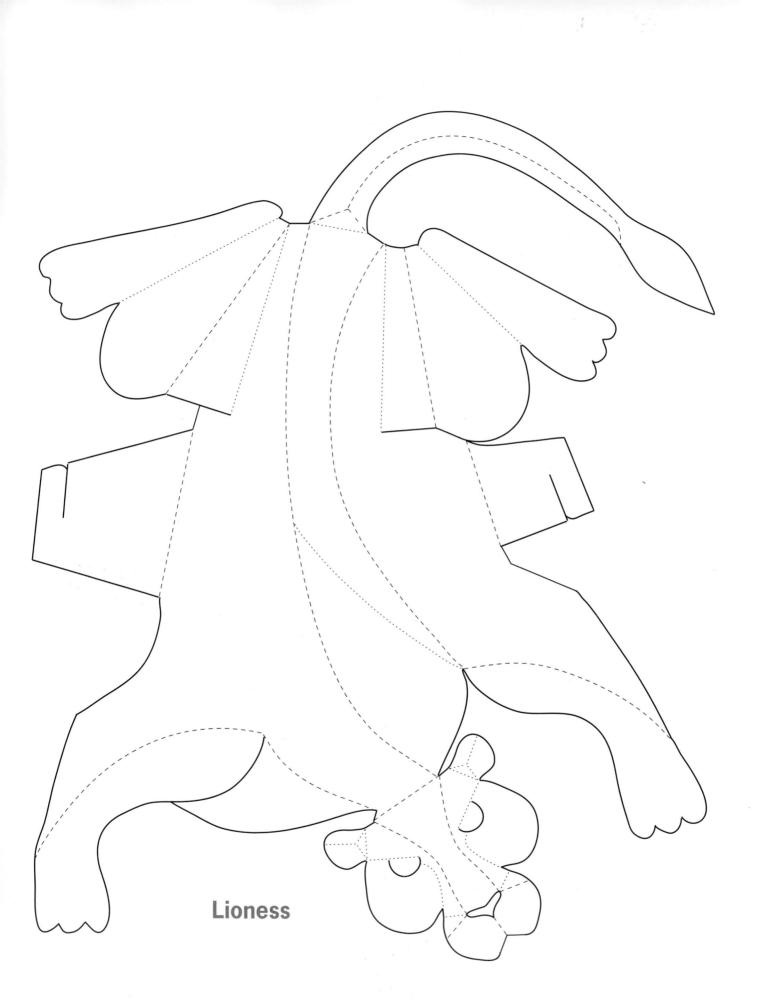

Lioness

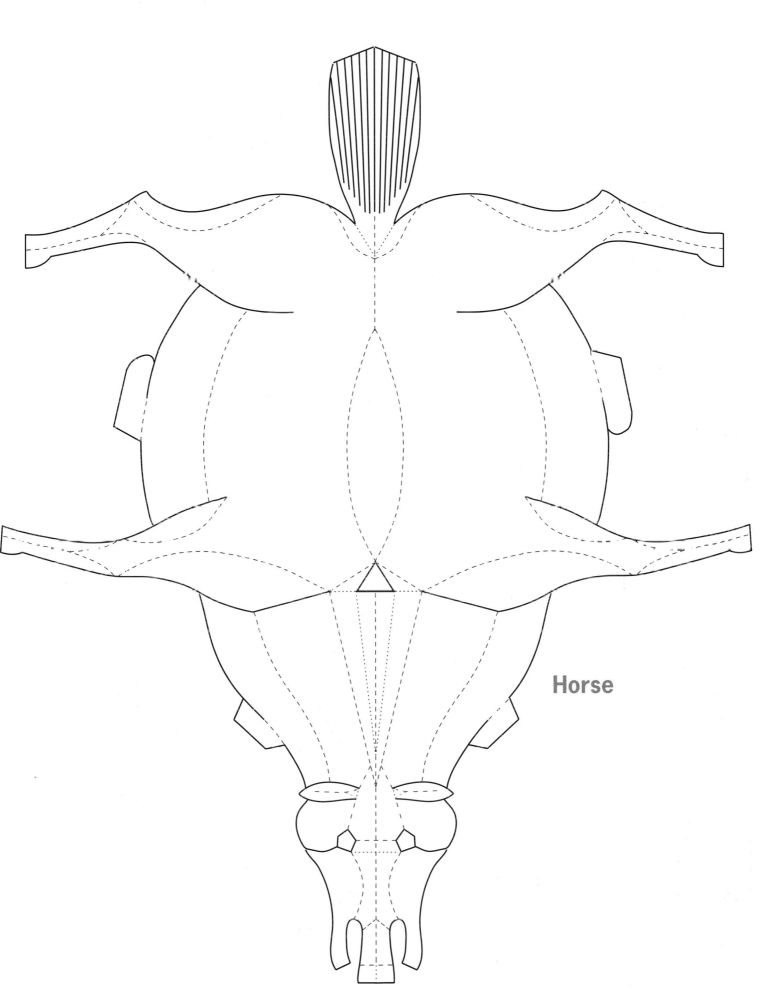

Horse

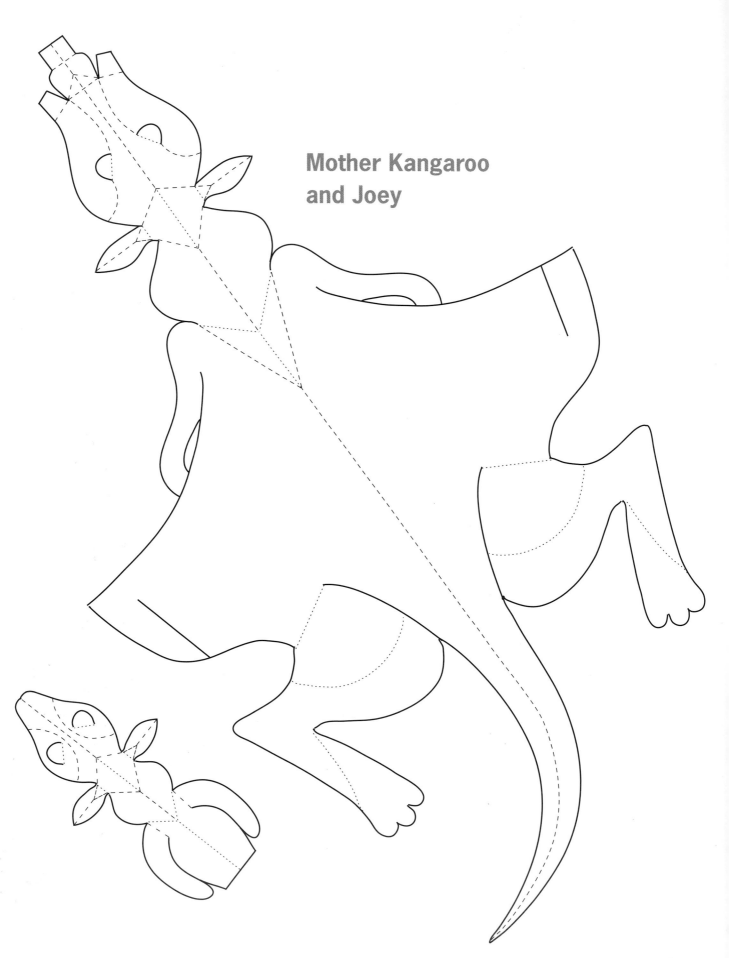

**Mother Kangaroo
and Joey**

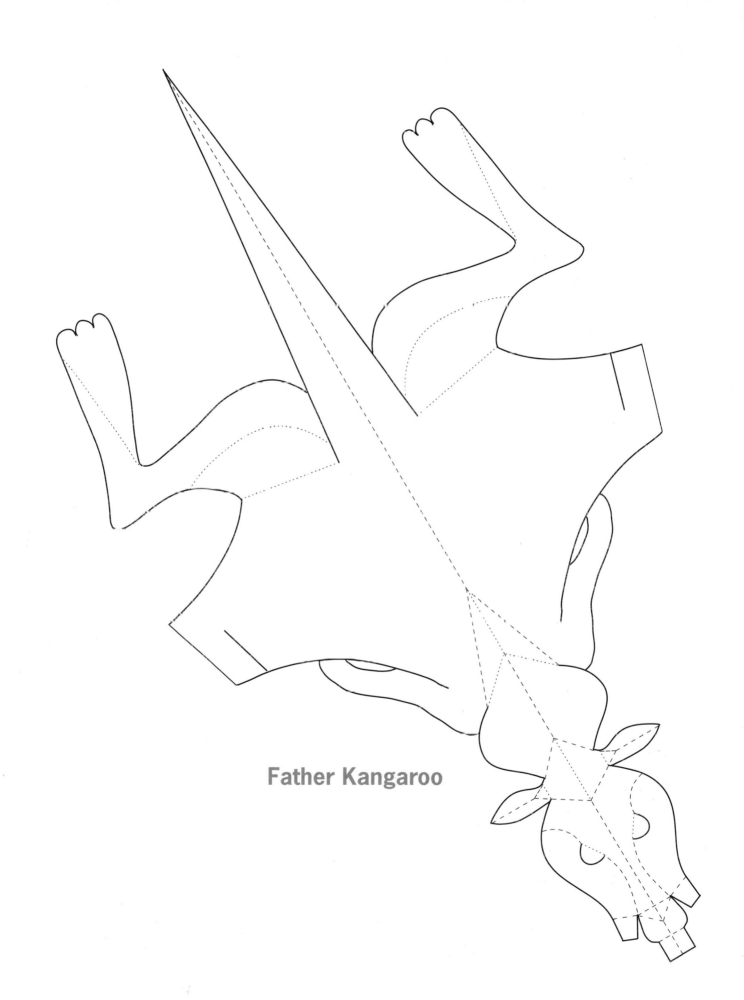

Father Kangaroo

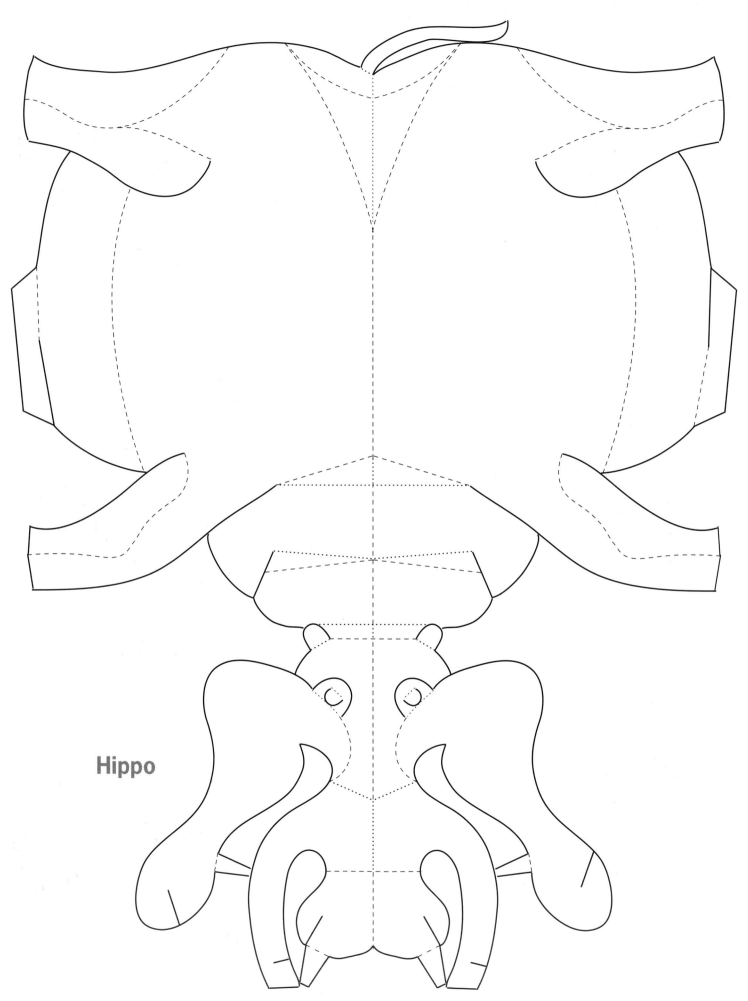

Hippo

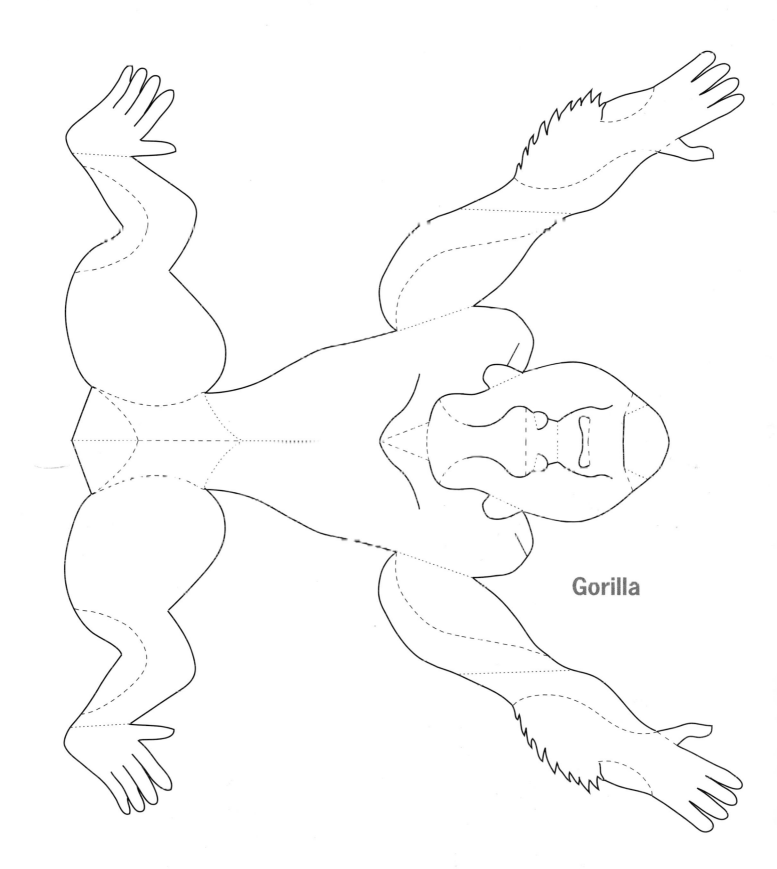

Gorilla

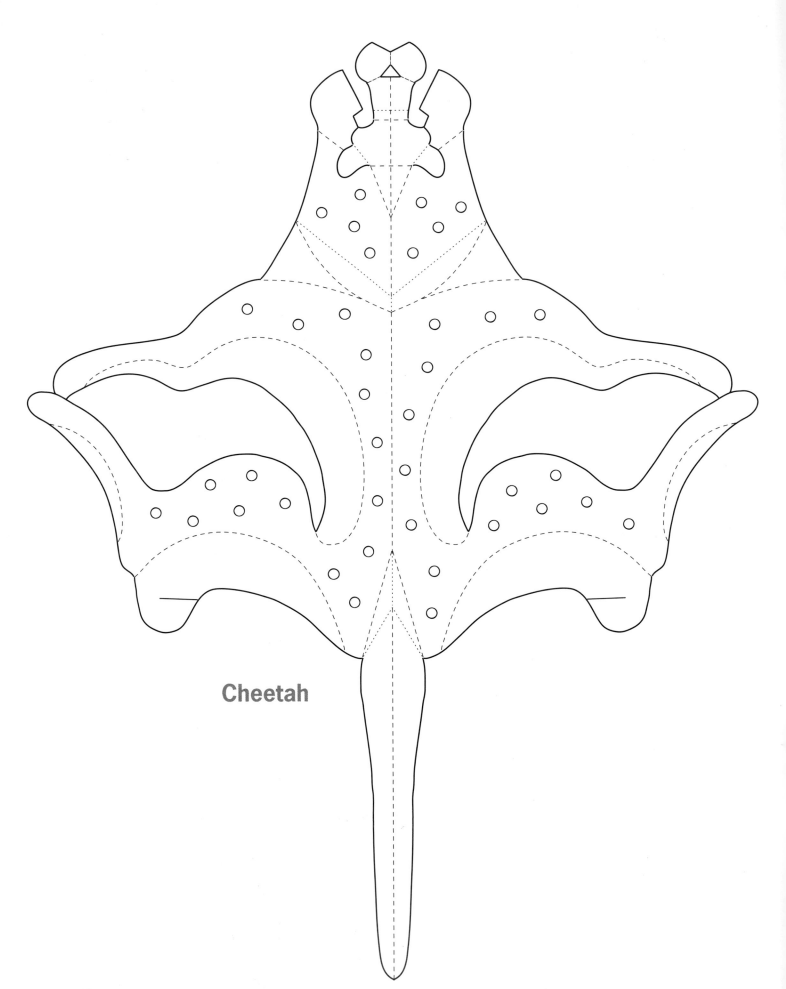

Cheetah

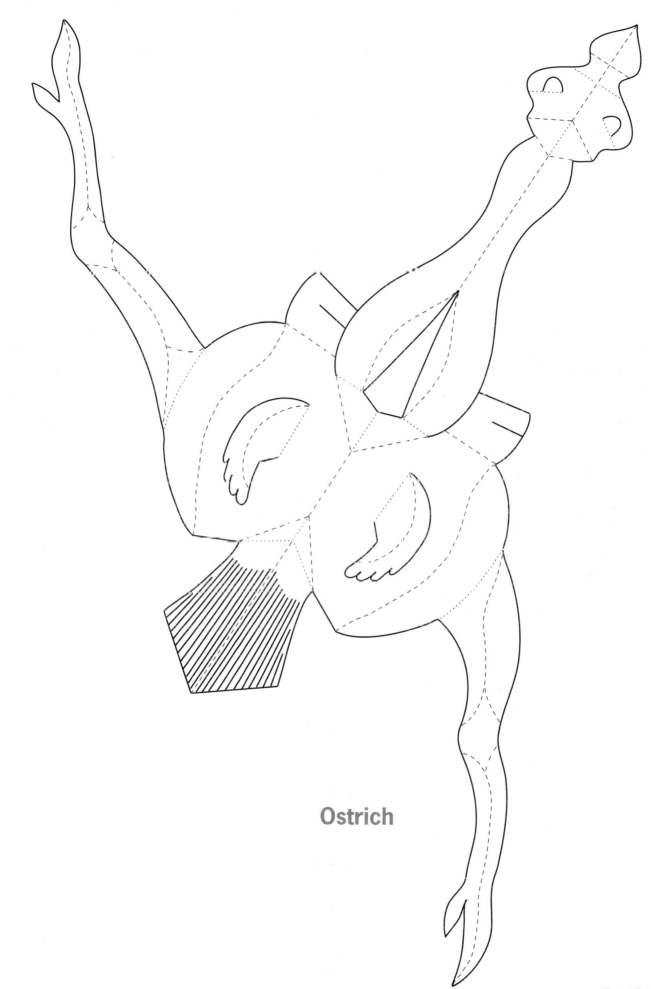

Ostrich

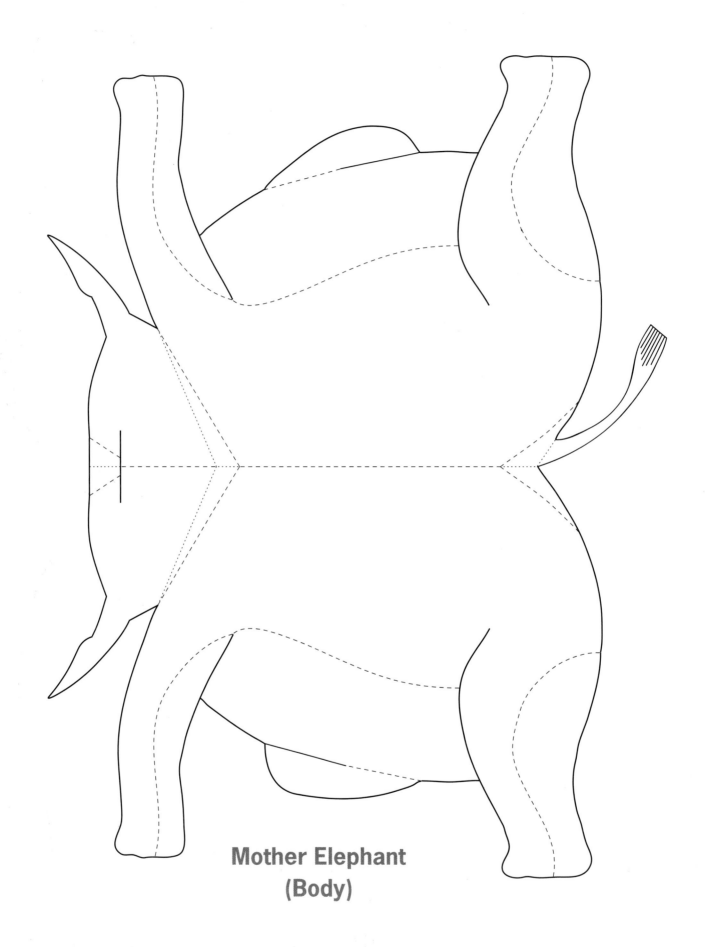

**Mother Elephant
(Body)**

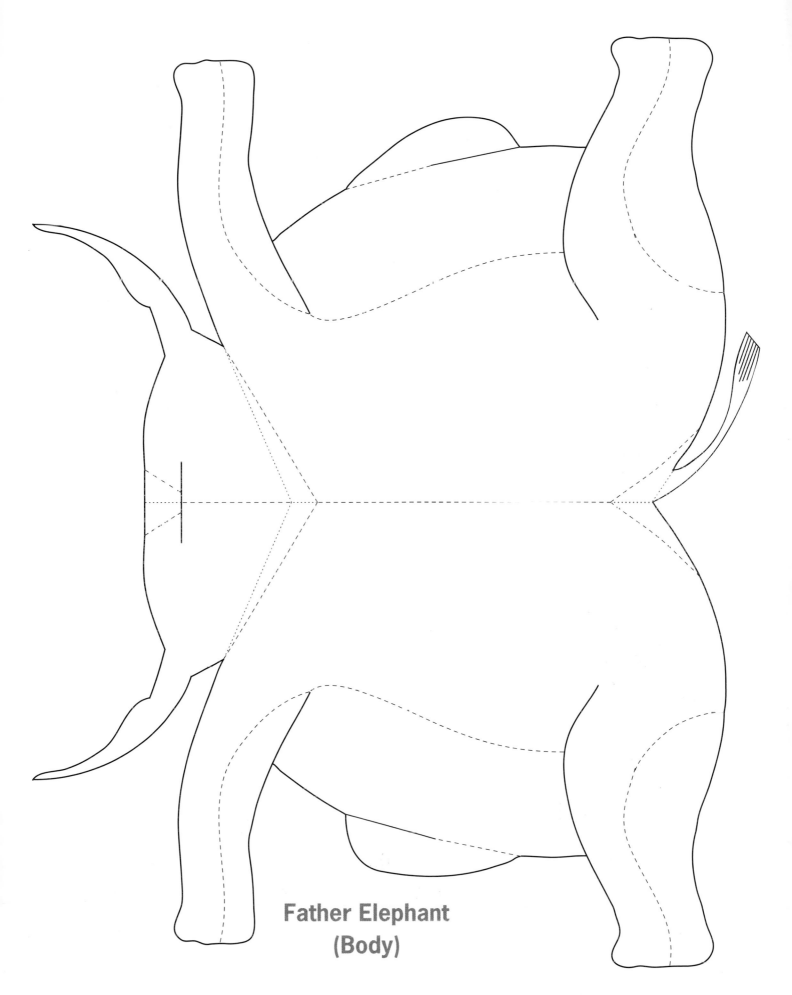

**Father Elephant
(Body)**

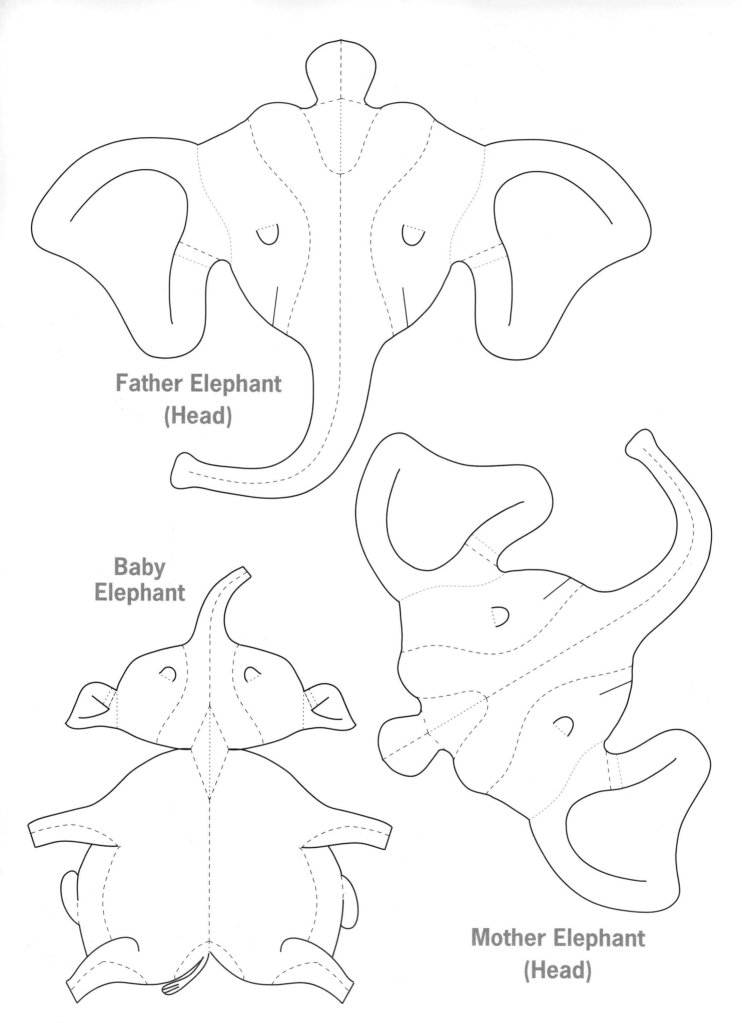

Father Elephant (Head)

Baby Elephant

Mother Elephant (Head)

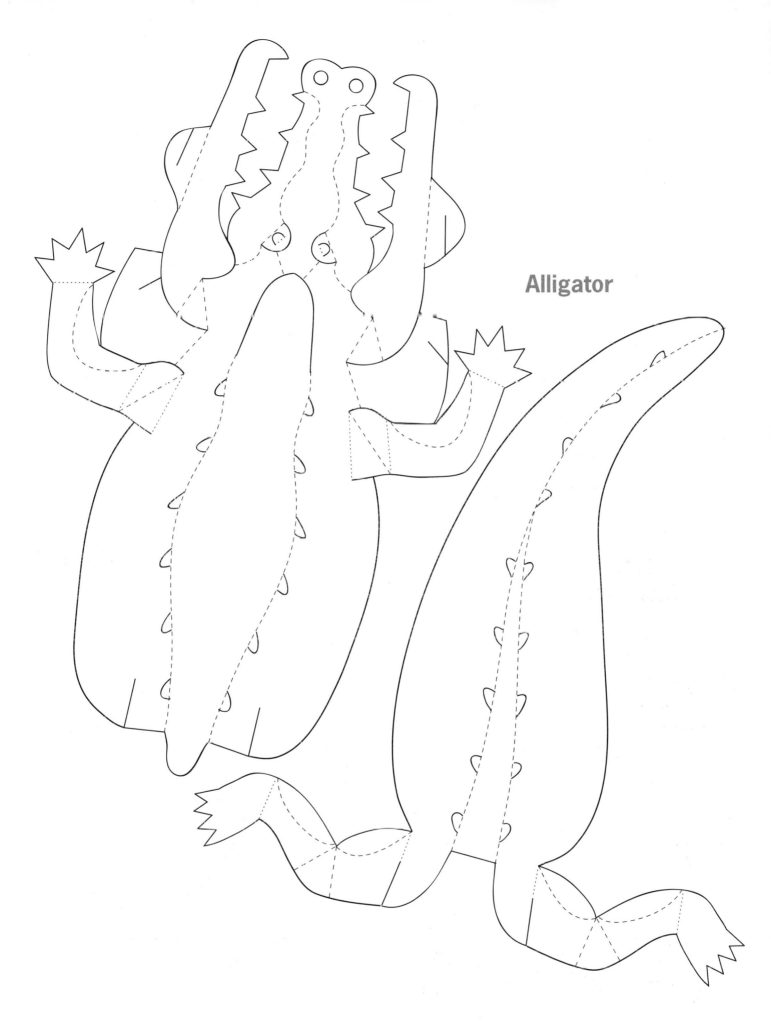

Alligator

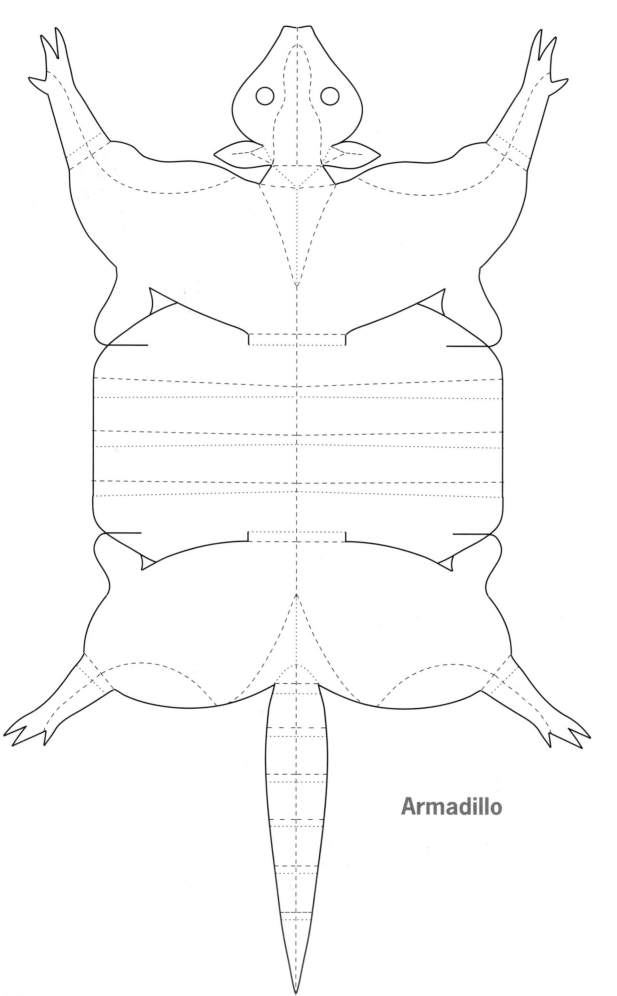

Armadillo

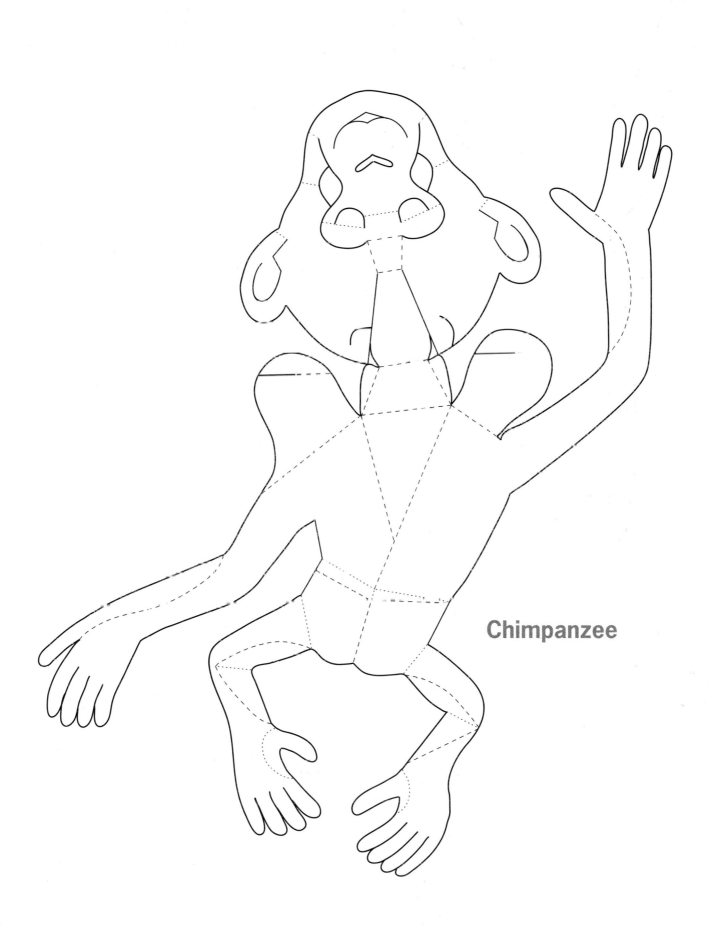

Chimpanzee

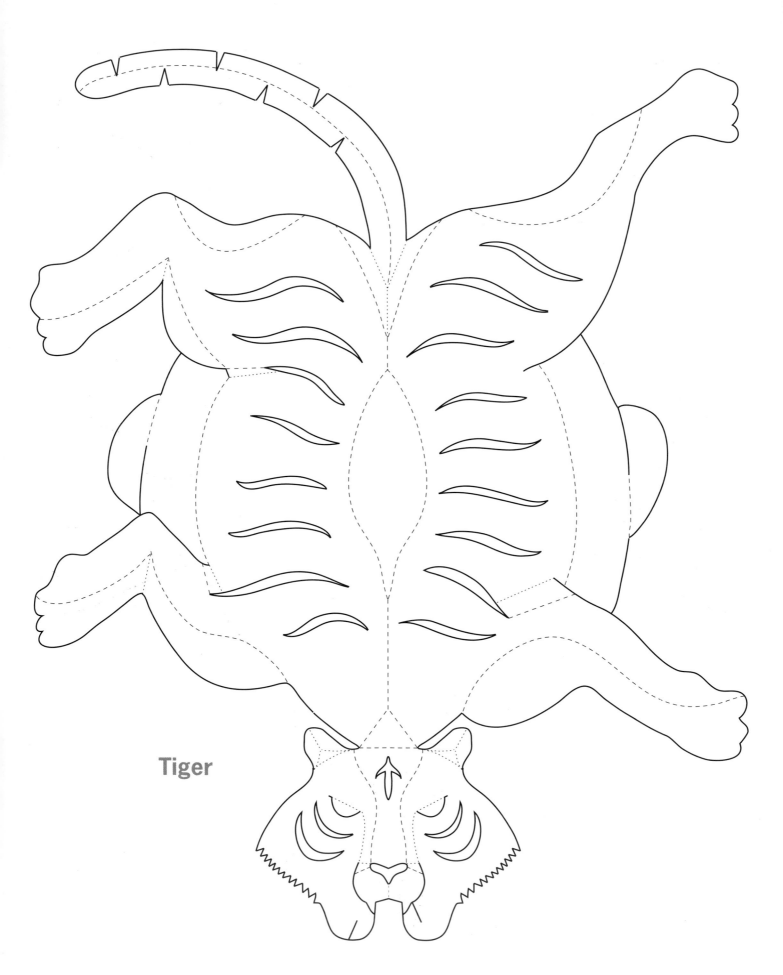

Tiger

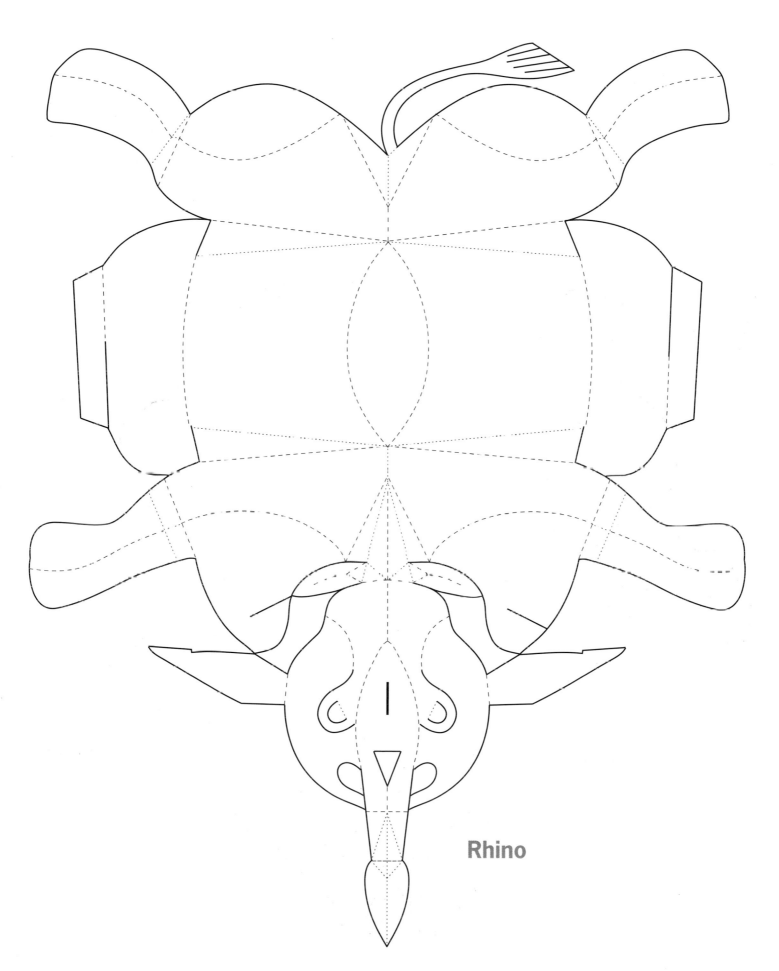

Rhino

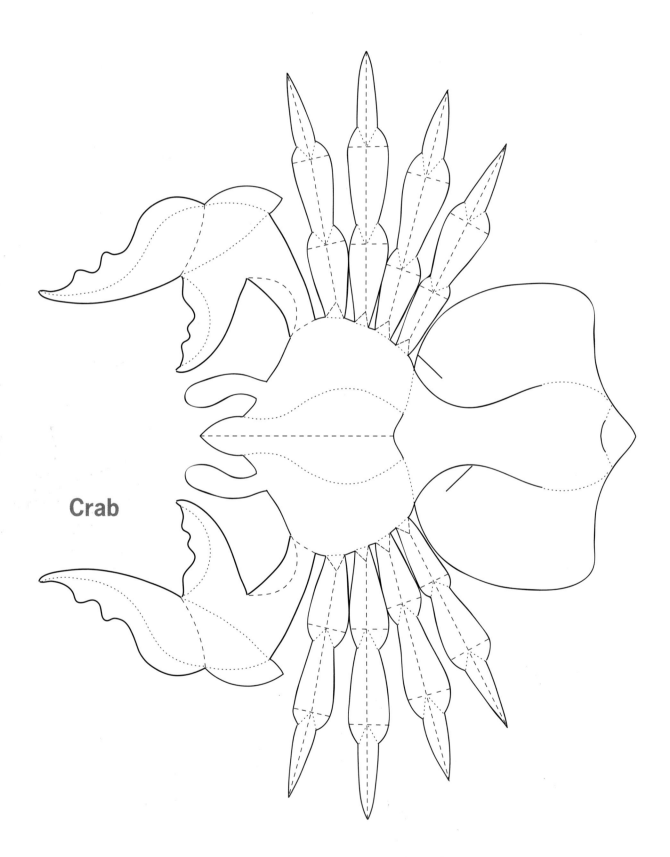

Crab

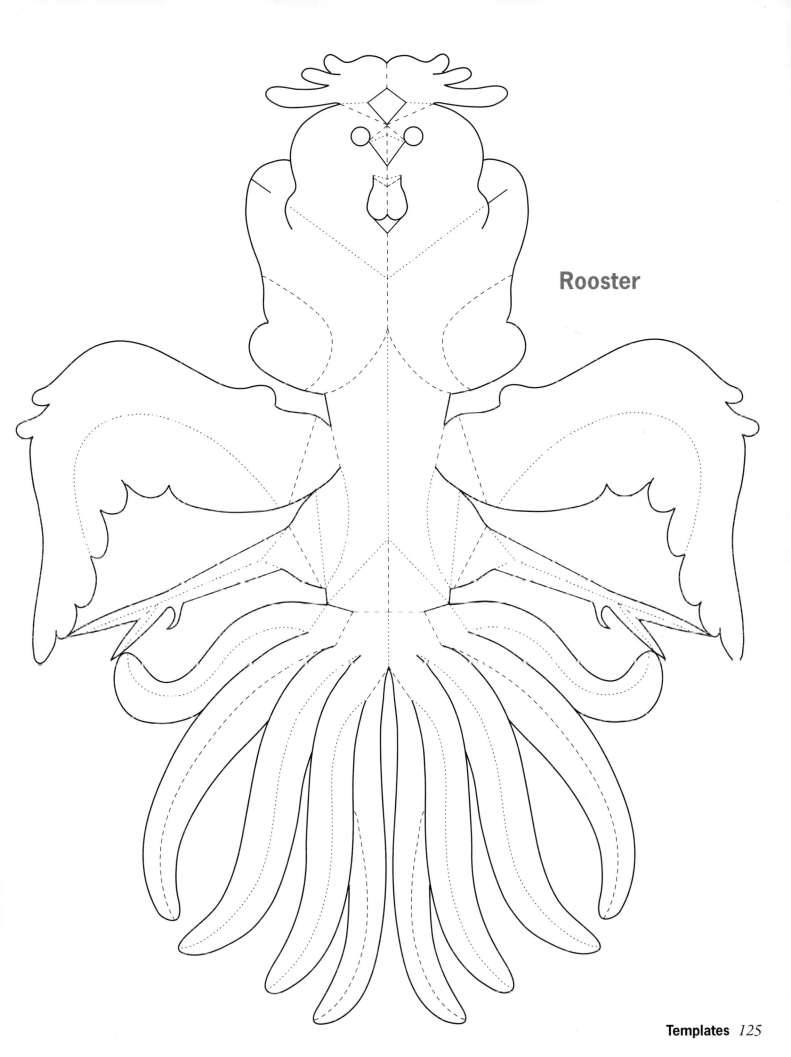

Rooster

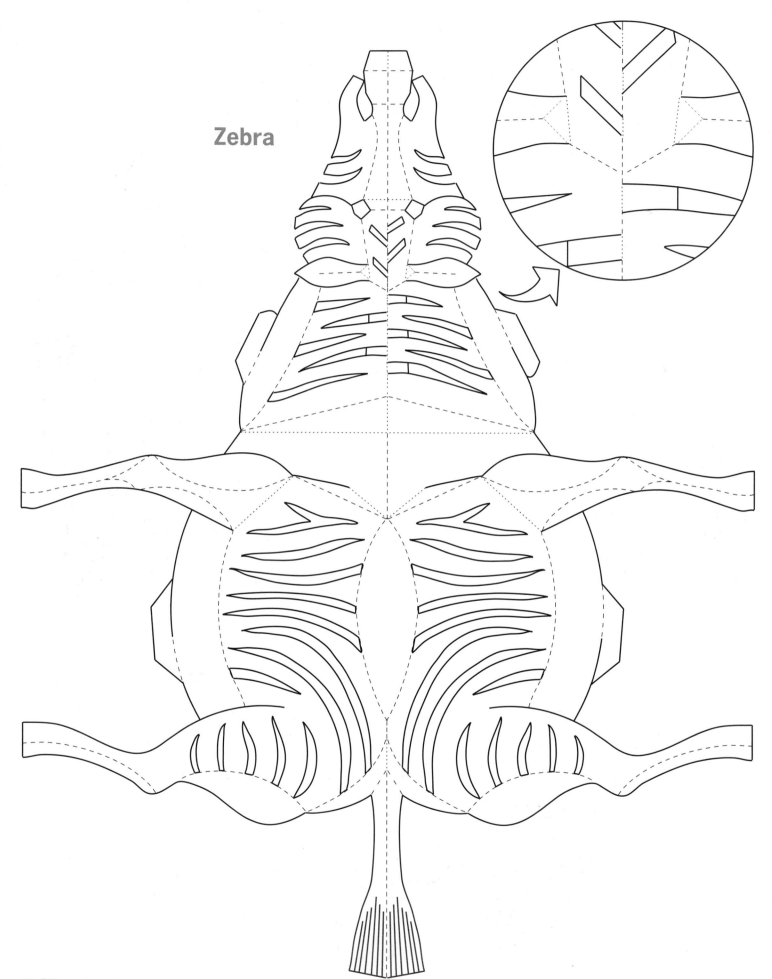

Zebra

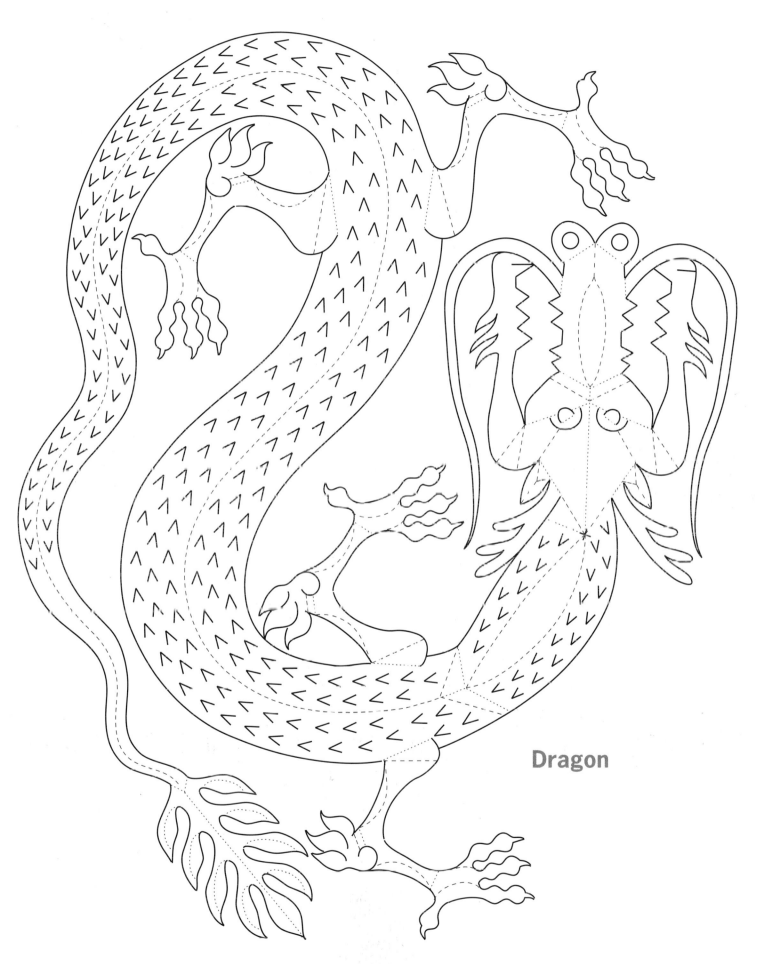

Dragon

Acknowledgments

The author would like to express his gratitude to the following people. Without their support, this book wouldn't have been possible.

Thanks to Lark Books for seeing potential in this project and providing me with valuable resources and insights. To Kristi Pfeffer, for her beautiful book design and her drive to make things happen. To Terry Taylor, for his sense of humor and hospitality, and to Steve Mann, for his photography skills. And thanks to Erik Johnson for adding a bit of flair to the projects with his limericks.

Thanks to Ms. Chilin Yu and the library staff at the Columbus College of Art & Design for their encouragement to move this project forward.

And finally to my wife, Nanette, for her faith in me and this project.

Index

Awls, 8
Cardstock, 7
Coloring, 13
Craft knives, 9–10
Cutting,
 Curves, 9
 Straight lines, 10
 Small circles, 10
Folding,
 Curved lines, 11
Mountain folds, 11
Pocket folds, 11
Valley folds, 11
Interlocking joints, 13
Kirigami, definition of, 6
Origami, 6
Paper punches, 10
Scoring, 8
Shaping, 12
Supports, 13
Symbols, 8
Templates,
Copying templates, 7
Display templates, 7
Texture patterns, 7